Dedication
The first book in this series is dedicated to the memory
of my late brother, Michael George Farace, an
accomplished actor, author, and photographer.

Digital Imaging

1.0

A RotoVision Book
Published and Distributed by RotoVision SA
Rue Du Bugnon 7
CH-1299 Crans-Près-Céligny
Switzerland

RotoVision SA, Sales & Production Office
Sheridan House, 112/116A Western Road
Hove, East Sussex BN3 1DD, England

Tel: +44 (0) 1273 72 72 68
Fax: +44 (0) 1273 72 72 69
Email: sales@rotovision.com
www.rotovision.com

ISBN 2-88046-517-6

Book design by Melanie Edwards at navyblue

Production and separations in Singapore by ProVision
Pte. Ltd.
Tel: +65 334 7720
Fax: +65 334 7721

Capturing the Image

Joe Farace

RotoVision

Capturing the Image

Joe Farace

Contents

Gallery

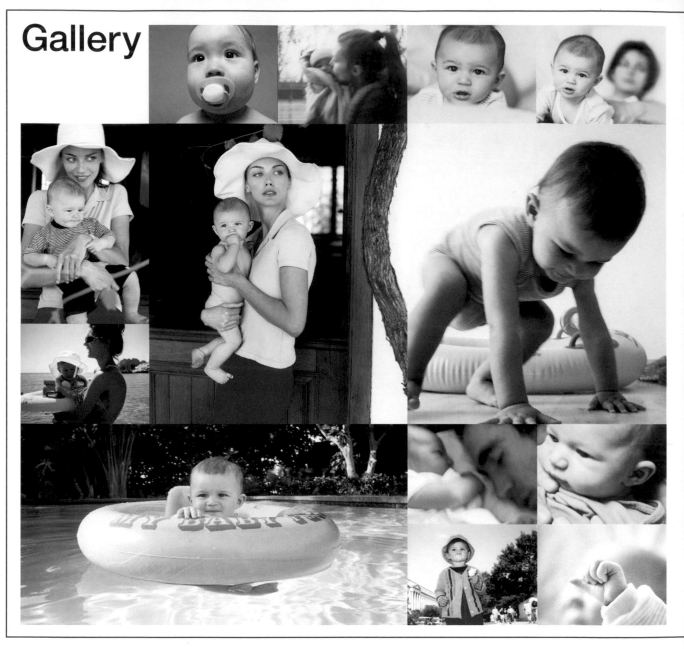

Introduction

Travelling closer and closer to the edge of the digital frontier? Let us help you cross that line! We've written this book to help you explore the opportunities available to you in this new age of digital technology.

Starting with the basics, we'll clearly explain all those "techie" acronyms, decipher the wild world of scanners and give you tips and tricks for working with digital cameras. We'll even give you a guide to using image-editing tools—giving you ability to finally create that perfect image.

Go on, take the first steps.

Digital imaging & you

Like traditional photography, digital imaging begins with capturing the image. The complete process is composed of four different aspects: acquisition, manipulation, output, and presentation. The Digital Imaging series of books is organized around these four parts. This book, the first in the series, is based on the first concept, acquisition.

Acquisition

Photographers have always employed a number of euphemisms to describe how they capture images. You hear about "shooting" brides, "taking" pictures of kids, and "snapping" photos of pets, so it's not surprising that digital photographers have also developed a language of their own. Instead of shooting photographs, they "acquire" or "capture" images, and there are many different ways to accomplish that goal. In this book, new digital imagers will learn that there is no one perfect way to create digital images. Just as when working with silver-based photography, you need to match the tools to what you are trying to accomplish with your image. The emphasis of this first book in the series is on image capture. It looks at the hardware, software, and processes available to help you create original digital images or digitize your existing silver-based photographs.

Manipulation

Digital imagers use image-enhancement and manipulation software to improve and change images, much as they would create similar effects using the tools and techniques of a traditional wet darkroom. More often than not, you will discover that achieving dramatic effects is far easier to accomplish digitally than by using light-sensitive paper and photographic chemicals. By digitally manipulating an image, you can improve its overall appearance by altering its brightness, contrast, and even sharpness. You can also use sophisticated tools and techniques to change it into something that previously could only be imagined.

Output

Image output is one of the most talked-about elements of the digital imaging process. In the past, the availability of photo-realistic printers was limited to professional use, and the devices themselves were quite expensive. That has changed. Now you can choose from a growing number of inexpensive desktop color printers and output your images directly from your own computer. The output quality from these devices is truly photographic, and their cost is surprisingly low.

Presentation

The last part of the digital imaging process gives the concept of output a worldwide dimension and opens the door to what you can do with your photographs after you've captured, manipulated, and output them. Using the Internet, you can now share digital images with friends and family anywhere on the planet. What's more, you can create presentations that combine your own still images with video clips, music, and graphics to tell a story.

What's in the book and who is it for?

This book has been written for photographers who already have some, maybe even extensive, knowledge about the craft of creating images. Throughout these pages, my assumption is that you already know how to use traditional photographic tools such as cameras, tripods, and filters to produce technically competent, well-composed images. As for your computer skills, I've assumed that you know that the oval thing with the cord hanging out from its back is a mouse, not a foot switch, and that you know how to turn your computer on. It's important that you understand the differences between what hardware is and does and how software provides an interface that lets you interact with computers. That's it!

Capturing the image

Like all of the other books in this series, Book One is aimed at the beginning and intermediate digital imager. Gurus should look elsewhere.

The book opens with an overview of the different types of digital imagers. This should help you determine where you fit into this universe. Knowing the kind of digital photographer you are helps determine the kind of computer hardware and software that you'll need to accomplish your digital imaging goals. Just as an advanced amateur and an aspiring professional photographer have different equipment needs, different kinds of "pixographers" need different digital tools depending on what their objectives might be.

Next I'll introduce you to some of the basic building blocks of digital imaging to help you understand and evaluate concepts that are explained later in the book. These introductions will often include technical terms and jargon that surround the digital imaging process. Don't let these buzzwords intimidate you. Digital imaging uses photographic and computer terms blended with buzzwords from the computer and printing industries. I've tried to define acronyms and buzzwords when they're initially encountered, but if any of the technical terms you encounter in these pages are unfamiliar to you, please refer to the glossary found at the back of this book.

Having the right hardware is a big part of the image-capture process, so it will be given special emphasis in this book. Recognizing that not many readers have an unlimited budget, alternative processes in which a vendor provides digitizing services are also examined. Since the creative use of digital tools also brings you face-to-face with the same kinds of quirks and idiosyncrasies that affect traditional photography, you'll find a collection of hardware tips and accessories scattered throughout the book that are designed to make digital photography more fun.

The internet

One of the most useful and practical assets that any digital imager can have is access to the Internet. While you don't absolutely need Internet access to get the maximum benefit from this book series, using the World Wide Web lets you search for information about products (and updates to products) and find help with specific digital dilemmas. That's why scattered throughout this book are the addresses of Web sites where you can find more information about specific topics or products. Keep in mind that the addresses shown were current when this book was published. It's possible that an address may have changed or even been discontinued since then. Don't panic! Instead, go to an Internet portal site such as Yahoo! (www.yahoo.com) or Excite (www.excite.com) and enter keywords associated with the missing Web site to find its current location.

One step beyond

One of the most difficult concepts that photographers new to digital imaging must cope with is the pace of technological change in this field. Grounded in centuries-old disciplines of optics and chemistry, many photographers struggle to keep up with the ever-changing digital imaging products and technologies. Reading this book will help keep you up-to-date on current digital imaging theories and practices. Magazines such as ComputerUser and Shutterbug have current information on digital imaging products.

Digital imaging won't completely replace silver-based imaging any time soon, but it is here to stay. I sympathize with those who worry about a decline in the quality of image-making, but every change in image technology—from the daguerreotype to the Advanced Photo System—has been more of convenience than quality. More importantly, I believe that digital imaging expands the democratization of photography like no technology ever before. Join with me now while we take the first step in digital imaging, capturing the image.

01 Getting started

The first part of the digital imaging process is acquisition—capturing the image—and it has two major aspects. First, you can convert your existing photographs, whether they are in slide, negative, or print form, into digitized versions that can be opened, enhanced, and output using digital technology. Second, you can capture your images using a digital camera so that these photographs exist only as electrons, instead of as silver-halide grains. Chances are that sooner or later you will use both of these methods to capture digital images.

You don't need to give up a favorite camera, lens, or film to "go digital." Photographers who have been creating images for some time and have built up an extensive collection of prints or slides can use some or all of the techniques found in this book to convert their existing images into digital form. Later on, you may decide that you want to capture some of your new images digitally. To do that you'll need a digital camera—you'll find helpful background information in this chapter. The good news is that you can be as digital as you want to be! (There is no bad news.)

While you can approach the digital imaging process in many different ways, you first need to be able to turn photographs into digital images. That's why Capturing the Image is the first book in the series. However, I recognize that not every reader will be at the same level of interest or experience in photography or computer use. The purpose of these first few chapters is to make sure that we are all speaking the same language.

Image making using digital technology, just like traditional photography, is made up of many trade-offs. The choices available depend on what kind of photographer you are and where your interests lie. Defining the type of photographer or computer user that you are helps determine the kind of hardware and software you'll ultimately require to accomplish your digital imaging goals. I believe that digital imagers can be classified into three distinct groups: beginner, intermediate, and advanced. Let's start by defining the differences.

Beginner

This user is somewhat new to computing and can be considered the digital equivalent of an amateur photographer just learning the craft. A beginner typically spends two hours a week or less working with an entry-level computer. Beginner software usually includes word processing and spreadsheet programs, often through packages such as Microsoft Office or AppleWorks, as well as basic graphics applications.

Intermediate

This type of user has a more powerful computer and may spend four hours a week—maybe more—on the computer. This user has Internet access and, more often than not, some kind of photo-quality printer to produce output. The intermediate user works with slightly more complex graphics packages, including programs such as Adobe PhotoDeluxe and desktop publishing software such as Corel's Print Shop Deluxe.

Advanced

This type, sometimes called a "power user," spends more than four hours a week on the computer, using professional-level programs like Adobe Photoshop. Power users' state-of-the-art systems have the fastest processors, biggest hard drives, and computer peripherals such as CD-ROM drives and scanners.

There are, of course, always exceptions to these three categories, but most computer users and digital imagers fit comfortably into one of them.

Three kinds of digital imagers

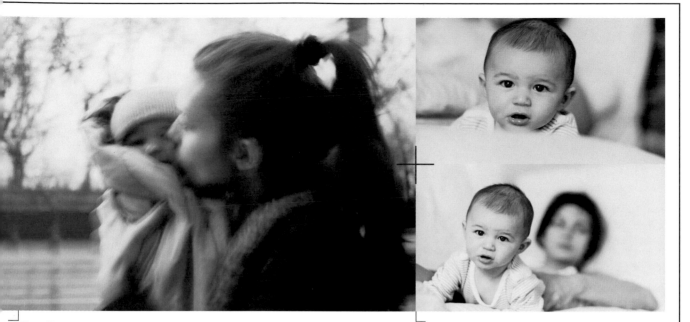

Above: Pinpoint sharpness isn't always necessary. Movement, as caught by the photographer, gives a sense of naturalness and energy to the image above.

Top right: What's your focus? By changing the focus, these two images show completely different results. The image above is squarely focused on the baby in the foreground.

Bottom right: By widening the lens to include more of the background, the second image's composition is more comprehensive.

Don't get "versionitis"! Readers should not be concerned about software version numbers of specific model names for hardware products that are mentioned on these pages. It's more than possible that a specific program will have been updated between the time I wrote this and the time that you read it. That's why no version numbers appear for any of the programs mentioned in this series. Be assured that no matter what version you eventually use, the software that appears will accomplish what I show in this book and maybe a bit more. When a specific camera or scanner model is mentioned, it is only to provide an example of how this particular device functions or what its specifications may be. By the time you read this, some digital imaging hardware is likely to have different model numbers, too. Don't let that put you off. Any hardware that appears in the book is typically an indication of a class of products produced by the company whose specific model is shown.

Hardware

The point of mentioning these categories at all is that the kind of digital imager you are ultimately defines the kind of equipment—hardware and software—that you will need. Using an analogy from traditional photography, if you're interested in making close-up images of flowers, a 500mm lens would not be an appropriate tool. Working with appropriate tools is just as important for digital imagers.

Always buy the most powerful computer system that you can afford. Since everyone's budget is different, this approach will result in different machines for different kinds of users. By "powerful," I'm referring to the major components of a computer that have an impact on how easy it will be for you to work with digital images.

Central processing unit
The CPU chip is the heart of your computer, and its most important aspect is how fast it processes data. Its speed of operation is usually stated as "clock speed" and is measured in thousands of cycles per second or, megahertz (MHz). Think of clock speed as the horsepower rating for the chip—the faster the clock speed, the faster the CPU can process data. The clock circuit of a computer uses vibrations that are generated by a quartz crystal, not unlike the one in a quartz wristwatch, to generate a stream of pulses to the CPU.

Hard disk
A computer's hard disk, or hard drive, consists of one or more rigid, nonflexible disks. It has a read/write head or uses multiple heads with multidisk drives. You can access this data whenever you want, and it's still there after you shut the computer down. Think of your hard disk as a file cabinet that holds all the data inside your computer—and size does matter. Fortunately, the price of higher-capacity hard disks has dropped as fast as the digital imager's need for greater capacities has grown.

Random-access memory
RAM is that part of your computer that temporarily stores data while you're working. Unlike a hard drive, this data is volatile—if you lose power or turn off your computer, the information disappears forever. The software that runs the computer and enables you to do digital imaging requires a certain minimum amount of memory. If you don't have enough, the computer will display an error message. One rule of thumb in figuring out how much RAM you need is to get as much as you can afford and twice as much as you think you need.

When working with digital images, you'll find that your computer needs greater capabilities than those needed for the average task. As a point of reference, look at the lowest-priced computer you see on sale and make a note of its capacities in the three critical areas mentioned above. If you can afford it, make sure the specifications for the computer you choose exceed these levels; how much more depends on your budget. Working with a slower, smaller-capacity machine does not mean you won't be able to work with digital images, but, as the traffic reporters say, "Expect some delays."

Top: They may not look large physically, but today's hard disks have the capacity to store hundreds, even thousands, of digital images. The real trick is not just storing them, but finding a specific image when you need it.

Bottom: Look at the camera! Modern images often show their subjects looking anywhere but the lens. Have you ever noticed that the best family pictures are those taken after the "regulation" regimented ones?

Right: Long vertical shots are often the most dramatic.

Tip: Be a joiner
No matter what your level of experience, one of the best ways to increase your skills is to join a users' group. These organizations are really fan clubs whose members have the same kind of unbridled enthusiasm found in any fan club. Users' groups are made up of people with all levels of computer expertise who may have the same kind of machine you're currently using and who are willing to share their successes and mistakes. After attending a few meetings, you will learn things to help you with your own digital imaging projects, and you just might even make a friend or two. Information about local groups can be found through computer dealers and regional computer publications such as ComputerUser.

Software

Many computer users think of image-editing software, such as Adobe Photoshop, as a tool for creating unrealistic, fantastic images, but the software is really an extension of the traditional wet darkroom. The new digital darkroom offers photographers many advantages over chemical-based methods. For example, it's far easier to convert a color photograph digitally into what computer users call "grayscale" and photographers call "black and white" or "monochrome" than by using photochemical means. Image-editing software also can be used to turn a blue sky to purple or simply to adjust contrast, to brighten or darken an image much as you would in a traditional darkroom. With many image-editing programs, you can use the digital version of traditional dodging-and-burning techniques.

Photographers who have worked with different papers and developers in the darkroom will find that the ideal image-editing software may similarly be a combination of different products from different manufacturers, each with their own unique characteristics. Whether you want to accomplish realistic image processing or create something that exists only in your mind's eye, you're going to need the right tools.

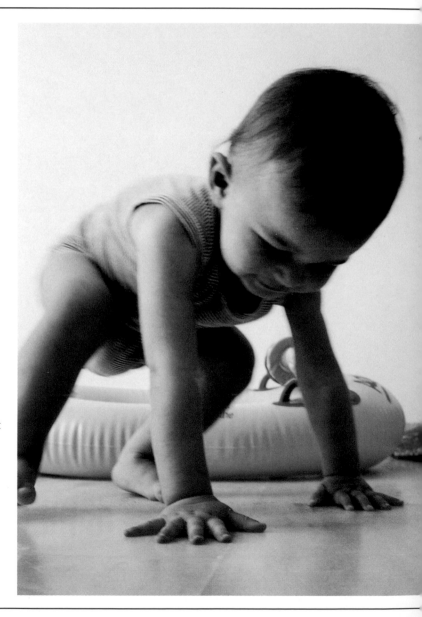

Acquiring images

While hardware turns real-world images or your existing photographs into digital images, software makes them available to you to enhance, manipulate, and print. Image-editing software is, among other things, your gateway to digital images that you may have captured using many different techniques. To understand the capture process, it helps to understand how images are brought into your computer with image-editing software.

Using the open command

The simplest way to open or read a digital image file is by using the Open command found in the File menu of your image-editing program. To use this command, all you have to do is select Open, and in the dialog box that appears, browse through menus until you find the file you're interested in. Click on the file name with the mouse and either click the "OK" button or hit the Return key, and the image will appear on your screen. In Windows select Open, and in the dialog box that appears, browse through menus until you find the file you're interested in. Click on the file name with the mouse and either click the "OK" button or hit the Return key, and the image will appear on your screen. The Windows version of Adobe Photoshop has an Open As command that can be helpful when opening image files originally created on other kinds of computers, such as an Apple Macintosh.

Buzzword alert: Dialog Box
Sometimes shortened to "dialog." This is an on-screen window that most programs use to allow you to communicate with the software and achieve a specific result. Often dialog boxes will have a preview window that displays a thumbnail of the selected image.

Thumbnail
This is an old design-industry term for "small sketch." In the digital photography world, thumbnails are small versions of your original photograph and are often seen in dialog boxes to show you a preview of an image stored on your hard disk.

Using plug-ins

One of the best features of image-editing programs is that most of them were designed with an open architecture to accommodate small software modules, called "plug-ins," that extend a program's standard features. Plug-ins are small bits of software that are stored in your image-editing program's "Plug-ins" folder; each time the software loads, the program checks to see which ones are available. That's why when you launch a program, you often see the names of the plug-ins briefly displayed. The judicious use of plug-ins increases the functionality of off-the-shelf programs and allows users to customize them to fit all kinds of projects.

Most plug-ins were originally designed to work with Adobe Photoshop, but you don't have to own a copy of Adobe Photoshop to use Photoshop-compatible plug-ins. Compatible plug-ins can be used with many programs, including Ulead Systems' PhotoImpact, MetaCreations' Painter and Art Dabbler, Apple Computer's PhotoFlash, Pixel Resource's PixelPaint Professional, Macromedia's xRes, MicroFrontier's Color It! and Enhance, and Corel's PhotoPaint. Even freeware image-editing programs, such as NIH Image, support Photoshop-compatible plug-ins. Most compatible plug-ins also work with Adobe's consumer-oriented PhotoDeluxe program. Other graphics programs, such as Adobe PageMaker, Deneba's Canvas, Equilibrium's DeBabelizer, Macromedia's Director and FreeHand, and also Strata's StrataVision 3D accept Photoshop-compatible plug-ins. Many programs have plug-in capabilities that allow you to acquire digital images. Like the Open command, some are found in the File menu of your image-editing program. Here are a couple of the most popular:

Import

This kind of plug-in is accessed through an image-editing program's File>Import menu. Formerly called "Acquire," Import plug-ins open an image and allow users to interface with scanners, video frame-grabbers, digital cameras, and even other image formats such as Kodak Photo CD.

Format

Sometimes called "File" or "Image Format," these plug-ins provide support for reading and writing additional image formats that are normally not supported by the program that you're using. The function of Format plug-ins is visible in the Open, Save As, and Save a Copy dialog boxes.

Using software

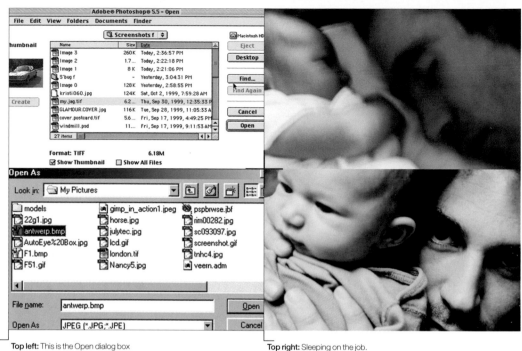

Top left: This is the Open dialog box in the Mac OS version of Adobe Photoshop. In addition to a scrolling window that lets you select an image file, the box also displays a thumbnail (small image) of the photograph, along with a notation of the file type and its size.

Bottom left: The Open As dialog box in the Windows version of Adobe Photoshop lets digital imagers open image files created with other kinds of computers. Notice the lack of a thumbnail display in this dialog box.

Top right: Sleeping on the job. Natural scenes, like the one captured above, are emotive and enduring.

Bottom right: In your face. Direct eye contact can be powerful and effective and is often employed in photographs taken for advertising campaigns.

This chapter takes a look at the building blocks of digital imaging. Just as any book on traditional photography would begin with a look at the photochemical relationships that produce images on film, this chapter takes a look at the electrons that come together to form digital images. While these two processes might seem worlds apart, there may be more similarities between digital and film-based images than you might think. It all begins with a single concept: resolution.

02 **Pix into pixels**

In general usage, the "resolution" refers to how sharp or, as some people put it, "clear" an image looks on a screen or when it's printed. Any discussion of resolution must begin with a look at two concepts that ultimately determine what most people will agree is resolution.

Bits and pieces

A "bit" is the smallest unit of information that a computer can process. Because computers represent all data—including photographs—by using numbers, or digits, they are digital devices. These digits are measured in bits. Each electronic signal becomes 1 bit, but to represent more complex numbers or images, computers combine these signals into 8-bit groups called bytes. When 1024 bytes are collected, you get a kilobyte (K). When you combine 1024 kilobytes, you have a megabyte (MB).

Bits are important to digital imagers because they are used to measure two important resolution components: file size and color depth. File size is one of the most overlooked components of digital images. In a few pages, you'll discover there are many ways to measure an image's resolution, but, while file size is not the first aspect generally thought of, the size of a file in kilobytes or megabytes is a good measurement of an image's quality. While there may be exceptions, the larger an image's file size, the better its image quality will be.

Bits are important to computer peripherals, because you often find a file or hardware device referred to as 24- or 30-bit devices. A 24-bit image has 8 bits assigned for each red, green, and blue color. A 30-bit image has 10 bits for each color. "Less is more" doesn't apply to bits that are used in graphic files; more is always better. High resolution is not without some cost, though. As the resolution capabilities of a device increases, so does its price tag.

Top: Just a little "bit." By adding a little magenta to the black and white picture above, the mood becomes warm and welcoming.

Bottom: Gotcha. The clear focus of the fingers in the foreground is an interesting contrast to the softer background.

Understanding image resolution

Above: One way to see all of the details about a particular image's resolution is to use an image-editing program's Image Size command. The dialog box will display the file's size in pixels and inches as well as dots per inch. At the top of the dialog box, you will also see the file size shown. This image, although less than 4x5 inches in size, measures 6MB.

Buzzword alert:
Virtual memory
This is the ability of software to simulate more memory than actually exists, allowing the computer to work with larger files or more files at the same time. This means that you are using hard-disk space as if it were memory. If you're working with a digital imaging program that requires more RAM than you have installed, the virtual memory feature of your program or even your operating system (Mac OS or Windows) will go to your hard disk and grab the amount of space you need—just as if it were RAM—to temporarily store data. The downside is that the process slows everything down.

In order to understand color depth, you need to know what a pixel is. "Pixel" is short for "picture element." Visual quality—or resolution—is measured by the width and height of an image as measured in pixels.

A computer screen is made up of many thousands of these colored dots of light that, when combined, produce a photographic image. On the screen, combinations of pixels, called triads, produce all of the colors you see. A triad contains 3 pixels, one each for red, green, and blue. In a typical color monitor, three electronic "guns" fire three separate signals (one for each color) at the screen. If all three guns hit a single location, it appears white on the screen. If none hit a target pixel, it will be black.

The higher an image's resolution—the more pixels it has—the better its visual quality will be. An image with a resolution of 2048x3072 pixels has a higher resolution than the same image digitized at 128x192 pixels. You could even relate the size of an image as measured in pixels to film format. After all, you can photograph the same person or landscape using a 35mm or 4x5 camera, but the image quality will be noticeably better from the larger film format. At low resolutions, images have a coarse, grainy appearance, making them difficult to evaluate on screen.

An image's color depth (or bit depth) measures the number of bits of information a pixel can store and determines how many colors can be displayed at one time. Let's examine some examples:

1-bit: When a monitor can only display 1 bit per pixel, each pixel must be either black or white. This is called a monochrome system. These monitors are usually sharper than color models and they also emit less radiation than color monitors do. However, they are rare in today's computing environments.

4-bit: Some computers, especially older laptop models, offer 4-bit screens. This color depth translates into the ability to display 16 shades of gray or color.

8-bit: This version allows computers to display up to 256 colors. On an 8-bit system, images are not displayed with 100 per cent accuracy—photographs can look slightly posterized and consequently, less realistic. This system can produce a "pixelized" look that is not dissimilar to what you might see when viewing a grainy photograph.

16-bit: Theoretically, you should be able to get 65,536 colors in a 16-bit system, but sometimes the video card that controls the monitor can only devote 15 bits to color (5 bits per color channel), and the 1 remaining bit is used to overlay all of these colors. That's why you sometimes get only 32,768 colors.

24-bit: This is the method used for computers that can accurately display photographs. Each pixel on a screen

What is image resolution?

can handle up to 256 colors, which lets 24-bit systems display 16.7 million colors.

Image color depth, like almost everything in digital imaging, is constantly escalating, improving the image quality while lowering the cost. Later on in the book, you will see color depths of 36, 40, and 48 bits mentioned in regard to some devices.

Dots per inch

Just as when working with traditional film, there are many components to an image's resolution. In film, the final image quality is determined by the format, type of film used, and how that film is processed and printed. In digital imaging, the resolution will be determined by the resolution of the capture device in pixels, color depth, and dots per inch, and—along with the resolution of the output device—will affect how well the printed image looks.

Dots per inch (dpi) is another measurement of resolution that is used for images, as well as for hardware devices such as printers or scanners. If a device has a resolution of 300 dpi, it means that there are 300 dots across and 300 dots down. A printer with a resolution of 300 dpi can therefore print 90,000 dots of ink or dye in 1 square inch, and a 400-dpi printer can generate 160,000 dots. The tighter this cluster of dots is, the smaller the dots become. The higher the number of dots, the finer, or greater, the resolution will be. In addition to dpi, image resolution can also be expressed in pixels per inch (ppi).

Top: From pixels to pixie! The building blocks of all the colors you see on screen are based on red, green, and blue (RGB).

Right: Baby with attitude. Images taken sequentially make for a visual story.

Bottom: Changes in background color can be done in-camera by changing the lighting—or on the computer. Here a drop of red added to the background changes the appearance from sharp yellow to peach.

This is a simple example to show how resolution affects final picture quality is this. Take several pictures and digitize them at different pixel sizes—ranging from 64x76 to 4096x6144. Then resize these images to 512x768 pixels so they are now the same physical size. Now look at the results.

The point of this exercise is to show what happens when a lower-resolution photograph is even slightly enlarged. The pictures digitized at a higher resolution when made smaller still hold their clarity. The ones digitized at the lower resolution then enlarged lose their crispness. The file sizes of the sets of pictures remain the same—approximately 1.5MB but it is the resolution that shows the differences in appearance.

As in all computer applications, the resolution of a particular photographic image inevitably involves a trade-off. As a digital photograph's resolution increases, so does its file szie. Larger file sizes mean that your computer system requires more, too, starting with memory.

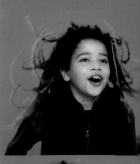

Near right: Get in the swing of it. Use lower resolution if you intend to use your images for the World Wide Web.

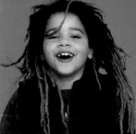

Below right: Open your eyes to the possibility of increasing the memory on your computer. Larger file sizes require more from your system.

Far right: Big smile now. Larger images, like this one shown, require a higher resolution to ensure they don't lose quality when printed.

Comparing resolution

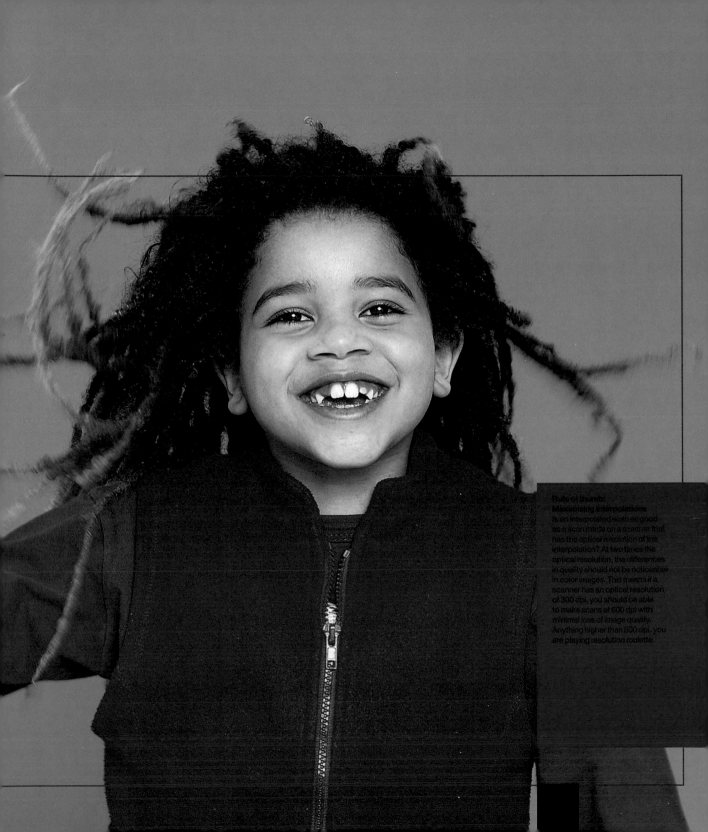

Resolution and hardware

You may have heard that image-manipulation programs are memory hogs, and that's partially true. In order to work with a digital photograph, Adobe Photoshop requires memory that is three to five times the size of the original image. To work with an 18MB image file, you need between 54MB and 90MB of RAM. Fortunately, the program has a built-in virtual memory scheme, called a scratch disk, that reduces RAM requirements by treating unused hard disk space as additional RAM. In this example, it means having at least 54MB of unused hard-disk space available. The program's Preferences menu lets you specify where the program should go to get this hard-disk space, and you can choose primary and secondary disks to use as scratch disks. The use of internal virtual memory schemes is not limited to Photoshop; other image-editing programs employ a similar scheme.

If you don't have enough real memory or scratch disk space, Photoshop gives you a "not enough memory to complete that operation" error message. Fortunately, there's an easy enough way to find out if you will have problems before you start working on a graphic image. Photoshop displays information showing how much memory that particular image takes in the lower left corner of any image window. By clicking on these numbers, you have the option of displaying File Sizes or Scratch Sizes. While File Size information is interesting, I recommend you keep the window set to show Scratch Sizes. The number on the left side tells you how much memory all open windows are using, and the number on the right tells you the amount of RAM that is available. If the first number is larger than the second, the difference is the amount of scratch disk space required.

Tip: GIGO
There's an old computer expression that is just as relevant today as when it was coined over thirty years ago: "Garbage in, garbage out." By maintaining the maximum quality when capturing the image, you can help ensure that you get a maximum-quality printed image.

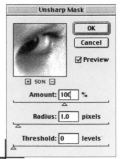

Unsharp Mask

OK
Cancel
☑ Preview

⊞ 50% ⊟

Amount: 100 %
Radius: 1.0 pixels
Threshold: 0 levels

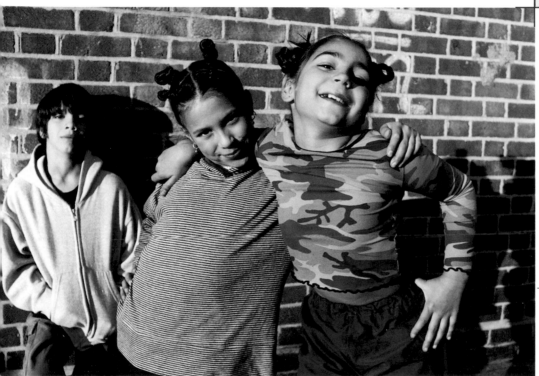

Above: The Unsharp Mask dialog box within Adobe Photoshop provides three sliders that emulate the controls used in a traditional darkroom. There's also a preview window, whose view of your image can be magnified so you can see the effect of the sharpening. Be careful, though—a light touch is required, and too much Unsharp Masking can create harsh edge effects. One rule of thumb is that larger image files accept greater amounts of Unsharp Masking than smaller ones. The Unsharp Mask commands that are found in other image-editing programs may have a different interface.

Left: Child's play! Natural lighting can leave images slightly "bleached." With Adobe Photoshop, you can reintroduce color to less than perfect images.

Resolution and hardware

Is it real or is it interpolated?

These days, image capture devices such as digital cameras and scanners are measured by their optical, as well as interpolated, resolution. Optical is the raw resolution that is produced by the hardware, while interpolated, sometimes called enhanced resolution, refers to the maximum dpi specification that a scanner and its software can produce for a selected image. For example, you may see scanners for sale that offer a maximum interpolated resolution of 4800 dpi, even though the hardware itself can only produce a 300-dpi image. This higher resolution is produced by the scanner's software when the image is scanned and delivered to the imaging application. When the resolution specified exceeds the optical resolution, the software interpolates the data by resampling the existing data using algorithms—mathematical formulae—to fill in the area between existing pixels. The best way to test a scanner is to evaluate the unit based on its optical resolution using different kinds of originals, such as color photographs, transparencies, negatives, and black-and-white artwork.

How does someone shopping for an image capture device know what the quality of the interpolation will be? The short answer is they don't. It all depends on the manufacturer of the scanner. To avoid direct comparisons, some companies avoid explaining the methods used to provide interpolated resolution. For scanners, the safest measure of quality is the horizontal optical resolution. Currently, 600 dpi is the most common resolution for business and graphic arts applications, but like everything in digital imaging, that is subject to change without any notice. For the growing mass consumer market, 300-dpi optical resolution scanners remain common—at least for the time being.

Riding the resolution carrousel

It's inevitable that you will encounter more than one type of resolution in your research of digital imaging products. For example, "device resolution" refers to the number of dots per inch that a device, such as a printer or monitor, can produce or display. Device resolution on computer monitor screens varies from 72 dpi on Macintosh OS computers to 96 dpi on Windows machines. Although this resolution measurement refers to a monitor's screen, don't confuse this term with "screen resolution," which refers to the number of dots per inch in the line screen that commercial printing companies use to reproduce halftone images. For example, 21-inch monitors can display more pixels than a 15-inch model. If you don't change the magnification level, what you see at 72 dpi is simply a closer look at the same image. Because the pixels are larger, it appears to be lower resolution. To confuse things further, monitor screen resolution is sometimes also measured in lines per inch (lpi). This last one is left over from television, and you still occasionally see this specification in ads for TV sets.

Top: In step. Another key feature of image-editing software is the ability to add solid color backgrounds to existing photos.

Below: All together now. With the aid of a computer, disparate photos can be montaged together seamlessly.

Right: There's more than meets the eye. Often, the finished image result is the combination of effective scanning and color manipulation.

Tip: Improving interpolation. One way to improve an interpolated scan's appearance is to use a command called Unsharp Mask that's found in Photoshop and other image editing programs. This oddly named function is a digital implementation of a traditional darkroom technique in which a blurred film negative is combined with the original to highlight a photograph's edges. In digital form, it's a controllable method for sharpening an image. Sharpening the image using the Unsharp Mask filter will add edge definition and crispness to your image.

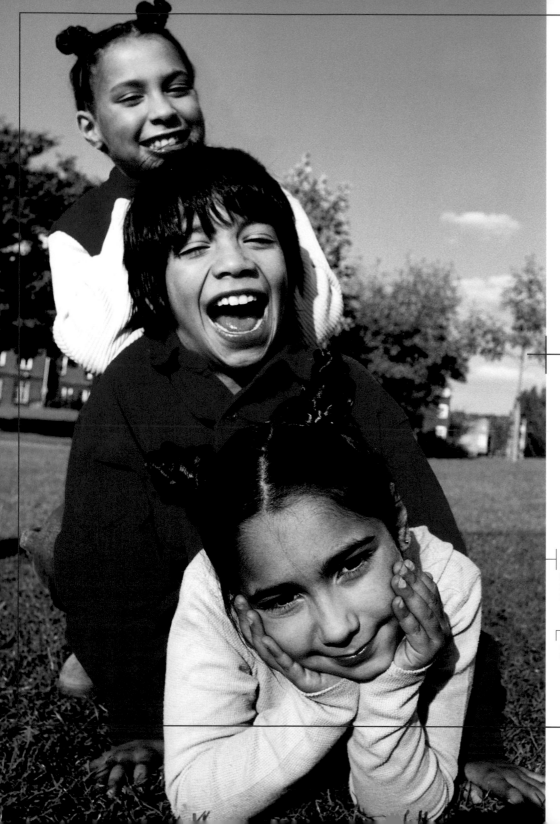

Left: The big three. Big, bigger, biggest—the higher the resolution, the more clarity you will receive in the final output.

Right: Come together. The more dots per square inch, the more intense the final result will be.

Matching resolution to output

The bottom line on resolution is that you have to match the resolution of the image acquisition device and software to the output. Requirements for World Wide Web applications, because they are based on monitor resolution, are different from working with four-color, magazine-quality output. By understanding resolution and what it means, you'll be in a better position to evaluate equipment purchases and make the right choices of digital imaging hardware or software.

The higher the resolution, the bigger the file becomes, which also determines how long an image takes to print. All of this goes back to how many bits, bytes, kilobytes, and megabytes an image file contains. It also completes the circular discussion of resolution that began at the beginning of the chapter with bits.

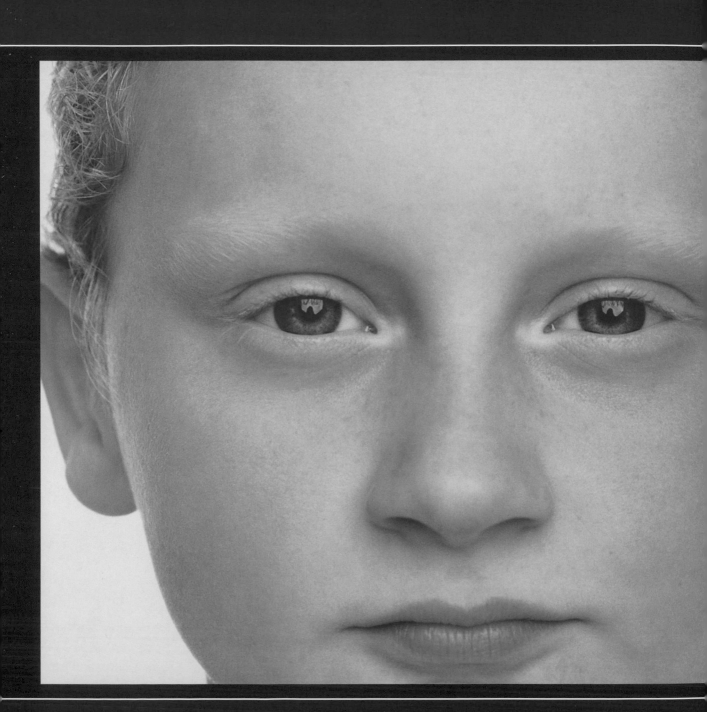

03 Digital cameras

There is one major and obvious advantage of using a digital camera over its film-based siblings: these cameras don't require film or any kind of photochemical processing. After creating images with a digital camera, you can transfer them directly onto your computer, where you can manipulate, print, or send them via the Internet. This kind of immediacy means that digital cameras have more in common with instant-processing cameras, such as those made by Polaroid, than with conventional film-based models. One class of digital cameras— I call them "video-centric"—even lets you display your freshly made pictures on any television set that's equipped with camcorder input jacks.

Classes of digital cameras

Digital cameras fall into three major categories: point-and-shoot cameras, field cameras, and professional studio cameras or backs.

The first group is the digital equivalent of the familiar point-and-shoot 35mm cameras, where ease of use and low cost are important. The people who use these lowest-priced digital cameras include real-estate agents, insurance adjusters, and other documenters who need to paste photographs into desktop-published documents that are then output on laser or ink-jet printers. Digital point-and-shoot cameras are also used by amateur photographers to take family and travel photographs. When combined with an online image-sharing site, such as Zing (www.zing.com), digital point-and-shoot cameras do a great job of allowing family members who may be located all over the globe to share special moments such as birthdays, weddings, and graduations.

The second group includes professional-level digital field cameras, many of which are based on conventional single-lens-reflex 35mm camera bodies from companies like Nikon and Canon. Since digital field cameras often use the same lenses as conventional film-based cameras, they can easily be integrated into an existing camera system. Prices currently start at $7000 (U.S.) and go up steeply from there. Digital field cameras are a popular choice for photojournalists and on-location photographers working on tight deadlines.

Between digital point-and-shoot cameras and field cameras lie the "bridge" cameras. The concept of a bridge camera is nothing new. Examples abound in film-based cameras, ranging from Nikon's 28Ti to the Contax T2. These precision models have their spiritual roots in cameras like the classic Rollei 35. Like their analog cousins, digital bridge cameras sometimes use a non-single-lens-reflex design. They feature quality lenses and offer resolution capabilities similar to what can be obtained with some lower-end digital field cameras. If you need relatively high-quality images for your digital photography applications and the price tag of a field camera seems too high, a bridge camera may be all you need.

The ultimate in image quality comes from digital studio cameras and backs, which are generally used by advertising photographers. Sometimes these digital images are converted directly into separations for four-color printing. Some studio cameras or backs require high-output lighting to shorten their long image-capture time to a reasonable few seconds, and they must be connected directly to a computer. These expensive cameras and backs deliver the film-like resolution needed for advertising, large prints, and catalog work. These high-resolution cameras often have five-figure price tags that make them unavailable for the average shooter, but the same downward price pressures that affect point-and-shoot, bridge, and field cameras are sure to affect studio cameras and backs. The only question is when.

Top: Having a ball. Image-editing software can help you "comp" or "montage" images together for joyous results. Here, the image has been manipulated by adding a solid background, duplicating images and rescaling.

Bottom: Bounce back. Sequential images, when added together, act as storyboards. Digital cameras give you the freedom to be both flexible and creative.

When shopping for a digital still camera, here are some factors to consider. The first is the camera's optics. It doesn't matter how good the camera's electronics are if the lens isn't adequate for the task.

Next, consider the imaging chip inside the camera. Much like camcorders, digital still cameras use CCD chips to capture light and convert it into images. In fact, some inexpensive cameras use camcorder chips that use rectangular pixels. In order to be displayed on a computer, these pixels have to be converted into square pixels—the kind that computer monitors use. This conversion can sometimes produce a "noisy" image, which can show up as a grainy or posterized section in a digital photograph. Typically, square pixels are found in the more expensive digital cameras, but they now can be found in more and more models under $1000.

All cameras use some kind of JPEG compression to store images. JPEG techniques compress an image into discrete blocks of pixels, which are then divided in half using ratios that vary from 10:1 to 100:1. The greater the compression ratio, the greater loss of quality you can expect. Be sure to check what compression ratios are used to store images in the camera. Lower compression produces fewer, better-quality images. For photographers trying to extract the maximum image quality from their digital cameras, the best option is no compression.

Make a resolution
A digital photograph's resolution is measured by the width and height of the image measured in pixels. The higher an image's resolution—the more pixels it has—the better the visual quality will be. At the introductory end of the digital camera spectrum, your choices range from 320x240 to 1600x1200 pixels. Some manufacturers, especially of low-end cameras, tend to slightly overstate their cameras' capabilities, sometimes stating the resolution as interpolated. You should always look for the "raw" or optical resolution specifications of a camera when making a purchase decision. A good rule of thumb is to get as much resolution as you can afford.

The key to making sure your images look good in print is matching the image size to how large it will be used in your output. A good test is to use an image-enhancement program, such as Adobe Photoshop, to measure the captured photograph's size in inches. A good rule of thumb is that you can use the image 50 per cent larger than that size with some judicious application of the Unsharp Mask command. When you push it past that size, the quality will degrade, much as it would enlarging a small-format negative to a large poster size using conventional darkroom techniques.

Most digital cameras offer more than one resolution option, allowing you to select from several resolution choices, depending on how the image will be used. In this way, changes in resolution may be compared to image format with traditional film cameras. An image printed at a large size that would be unacceptable if shot with a 35mm or Advanced Photo System camera will look much better if photographed on 4x5 or 8x10 sheet film.

Capturing the image
If you're familiar with the optical viewfinders in conventional point-and-shoot cameras, you'll be comfortable with their digital equivalents. Try out the

What to look for when shopping

different viewfinders and look for the old range-finder bugaboo-parallax problems. Computer users have a name for it: WYSIWYG (What You See Is What You Get). Some cameras substitute a color LCD (liquid crystal display) preview panel for the viewfinder, but many digicams have both. Casio started this trend, and more and more cameras use either an LCD panel or offer one as an option. Making pictures with an LCD-only viewing system entails using an extended-arm shooting technique, which you may either like or hate. Nevertheless, it's fun to use the built-in screen to preview images and delete the ones that didn't turn out so well.

LCD panels tend to shorten battery life (always a problem with digital cameras), but they are useful as an image-management tool. Not every image you shoot is a keeper, so you can extend the storage capability of the camera by periodically reviewing the images in memory and deleting the bad ones.

All cameras let you erase images, but there are different methods. Some erase captured images inside the camera, with the only option being erasing everything or nothing (not a great system); others let you erase the last image (better). Others let you selectively erase whatever image you want (very good), but only when connected to a computer. Recently I made three images with a non-LCD digicam. Only one was acceptable, but I didn't know that until I downloaded them the next day. That's why the erase button works best with LCD-equipped models. Get a camera with erase capability—that's most of them—but don't consider it a deal-breaker over resolution considerations.

Top: It takes two. One of the benefits of digital cameras is the ability to review the images taken and erase those that don't make the grade!

Bottom: Another perk of digital manipulation is the ability to remove backgrounds. In technical circles, the image that is left is called a "cut-out."

Top: The once over. Make sure you consider the quality of the optics before you purchase your digital camera.

Bottom: Smiles all around. The less compression you use when storing images, the higher quality the end result will be.

Right: Oh, no! The less expensive digital camera doesn't always make for the best buy. When you've taken that perfect shot—the last thing you want is grainy output. Be sure to consider all variables before you purchase.

Buying a digital camera

The number of images a camera can hold is based on the type of storage it has and the way it manages images. There are two basic kinds of image storage: internal RAM and removable media, sometimes called "digital film." When a removable memory card gets filled, you can pop another one in, much as you would change a roll of film. If you carry a laptop computer, you can also download images from internal memory as you fill up the camera with images.

Other considerations

For a long time, one of the most striking features of some digital point-and-shoot cameras is how little they looked like cameras. Although the current trend is toward more "normal"-looking—even retro-looking—cameras, some unconventional designs persist. That's why you should make sure the digital camera you're considering is comfortable in your hands by handling the camera long enough to determine if the controls are easy to reach and operate. If you don't feel completely comfortable with the camera right away, you're going to hate it later.

Some other considerations, such as a fixed-focal-length lens versus a zoom lens, are similar to decisions you have to make when purchasing a conventional camera. Be sure to ask questions about lens compatibility before assuming your existing lenses will work with an interchangeable-lens digital field camera. Lenses with maximum apertures smaller than f/4 can cause vignetting, so you may not be able to use every lens you own. There's more on the pros and cons of zoom lenses with digital cameras in the next chapter.

How the camera connects to your computer is important. The most common connection for point-and-shoot digicams is via your computer's serial port, but this varies by manufacturer, and the faster Universal Serial Bus (USB) is becoming more popular. You might want to get an inexpensive card-reader that lets you read removable media much like a floppy disk.

A camera with video-out capability is valuable because it allows you to preview images on your television or present them as a slide show. Many TVs now have front-mounted video-in jacks, making it easy to hook up your digital camera. That's why it's a good idea, before walking out of the store with a camera, to make sure you have all of the cables you need—even if you have to make a separate purchase. Through the basic design of a camera, manufacturers make a choice about how they think it will connect to your video system. Video-centric designs, from companies such as Fuji, include video-out jacks, allowing you to access images in much the same way you do with footage from your camcorder. Other companies have taken a computer-centric stance, assuming that the computer, not the video system, will be the preferred method for acquiring, manipulating, and outputting still and video media. Some professional field camera manufacturers provide their digital cameras with a continuous video mode that allows photographers to view their images directly on a video monitor before clicking the shutter. This instantaneous preview image is useful for studio photographers who want to check their lighting or show clients what an image looks like before it's captured.

Top: Hippie chic. The trend in digital camera design is "retro." Whatever camera you choose, be sure that it feels comfortable in your hands and that the controls are within easy reach.

Bottom: The top two. The two basic kinds of image storage are internal RAM and digital film.

Right: Something to yell about! When negotiating for your digital camera, ask the seller to throw in additional bundled software.

Lighting concerns

A digital camera's light sensitivity can vary from moderate to quite high, allowing you to shoot in very dim situations. You can compare it to choosing a film based on its ISO light sensitivity. Just as film is available in ISO speeds from 25 to 3200, some digital cameras have a control that lets you change the light sensitivity of the camera's image sensor by ISO equivalence. Some inexpensive digital point-and-shoot cameras don't offer a built-in flash, and in this case, higher light sensitivity

can help when the overall illumination is low. Along with higher light sensitivity comes lower image quality. This shows up in ways not dissimilar to conventional photography: reduced contrast, image noise, and muddy colors. Unlike silver-based images, these effects are lessened when a camera produces higher resolution digital photographs. Few professional-level field cameras offer built-in flash, but most are compatible with the sophisticated shoe-mount flashes that match the

film-based cameras many of them are derived from. Since field cameras are typically going to fit into an existing system, chances are you already have the kind of shoe-mount flash you need. As in silver-based photography, though, there's no substitute for good lighting.

Digital camera prices are constantly dropping, while capabilities are increasing. Depending on how you use the camera, you may be able to justify the cost in savings in film, lab costs, and the cost of travelling back and forth to the photo lab—something often overlooked when calculating total cost of ownership.

But all is not rosy for digital camera purchasers. One of the key problems in finding the right camera is the unrelenting rollout of new products. Each new digicam is better and less expensive than the one that preceded it. One industry insider told me that digital cameras have a half-life of four and one-half months! In real-world terms, this means that at just about the time you hear about a new camera, the company is getting ready to replace it. The company usually keeps the old camera in the product line-up and lowers its price to move remaining stock.

Digital camera manufacturers are in a tough spot. They have to keep raising the technological bar to improve their products, because if they don't, their competitors will. Unfortunately, this leaves many potential purchasers waiting for their favorite camera company to "perfect" the technology, and I think there's a sizable pool of potential buyers waiting for the market to stabilize. At the same time, actual purchasers feel they are being burned after buying a new camera, only to see the price drop a few months later.

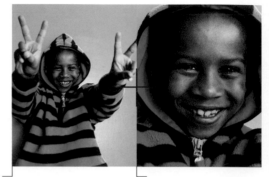

Left: Go "fourth." There are four main things you need to know when making your digital camera purchase. See the list on the right.

Right: "Hoodwinked." Expect that your digital camera will quickly become out-of-date. Technology is changing at an amazing pace.

The bottom line

Here's a short checklist of things you can do when shopping for a new digital camera:

1. Shoot a test image or two in the store, take them home on some other kind of removable media, such as an Iomega Zip cartridge, and print them using the same output device you plan on using.

2. If you have an understanding salesperson, you may be able to print the image using one of the store's photo-quality printers.

3. If these alternatives are not possible, buy it and try it. Many computer superstores allow you to return equipment for a full refund within a reasonable time, but make sure you get that policy in writing.

4. Evaluate the image quality using the printer or output device that you own or are planning to purchase in the future. Take into account any differences introduced by the paper and ink used in ink-jet printers, which can have an impact—positively and negatively—on image quality.

Lastly, don't be surprised or depressed when you discover that the "dream" camera you bought six months ago was just replaced with a new model that has better resolution and more features and costs less.

04 Working with digital cameras

Many people think that photography is reality.
The old axiom "pictures never lie" is not true—
especially since the advent of Adobe Photoshop—
and was never really true. Photography has always
been an interpretation of reality, and digital imaging
is merely the latest tool available to let you make that
interpretation. Images are created with a traditional
film-based camera using a simple process. Light
passes through a lens and is captured by sensitized
material—film—that records the image. With only
minor changes in the light-gathering technology,
that's essentially how a digital camera works.

I don't mean that literally. How an imaging chip converts electrons into digital images is a topic for a book written for power users, not a topic for this book. In this context, learning how to see like a digital camera means two things: overcoming all the preconceptions you may have accumulated over the years from shooting with film, and dealing with and overcoming some of the inherent limitations of the current crop of digital cameras.

Composing for the chip or the print

One problem that digital camera owners have in common with users of film-based models is that the shape of the image-capture area is, more often than not, different than the way the final image will be used. A bigger problem is that while the shapes and sizes of the 35mm and Advanced Photo System formats are standard around the world, in the world of digital image capture, there is no standard size or shape.

An image created by an Epson PhotoPC850Z, for example, has a resolution of 1600x1200, while providing an image ratio of 1.33:1. The Olympus C-2500L produces an image that measures 1712x1368, which has an aspect ratio of 1.25:1. By comparison, a 24x36mm image from 35mm film has a ratio of 1.5:1, but an 8x10 print has a ratio of 1.25:1. As you can see, that is much closer to what the Olympus digital camera captures than what is accomplished with 35mm film.

What this means to the digital imager is that less of the image has been discarded to create a finished print, which helps maintain image quality. Just as in making prints of images created with film, the least amount of enlargement creates the highest-quality image. The Olympus digicam is indicative of a class of cameras that produce an image closer to 4x5 and 8x10 images. What about 3x5, 4x5, and 5x7 prints, you may ask? You have just arrived at another consideration when choosing a camera. Look at what print sizes you are most likely to make, and get the highest resolution camera that you can afford that has an image ratio that matches your intended output.

Inevitably you will be faced with a mismatch of image shape and desired output shape. That's when an image-editing program's cropping tool comes in handy. Cropping tools typically have two modes:

Freehand cropping: This is the typical form of image cropping that allows you to crop a photograph from all four sides to include only the information you want.

Constrained cropping: Found on some image-editing programs, including Adobe Photoshop, this cropping option lets you input the finished image size and limits the cropping shape—and size—to only the dimensions and ratio that you have specified.

Learning to see like your digital camera

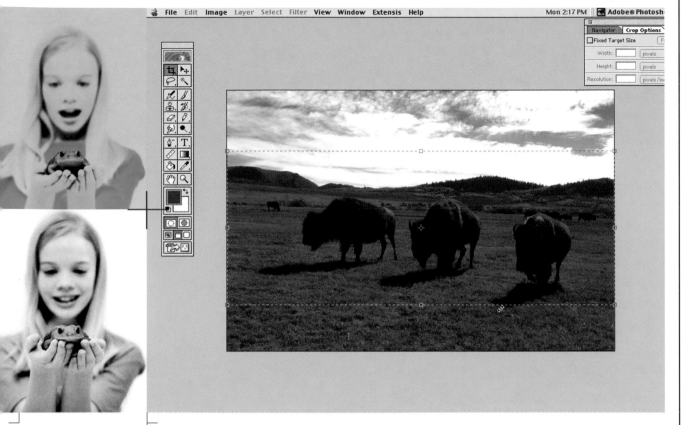

Top left: Princely pictures. To create the dream-like picture above, you can use Adobe Photoshop. First layer and fill with your chosen color then adjust the opacity and overlay.

Right: Field of dreams. By using the cropping tool, you can focus on the main subject and delete extraneous sky and foreground.

Bottom left: Here's the same image relatively untouched by the image-editing tools.

Lens considerations

The choice of a zoom or prime (fixed focal length) lens for a digital camera may be similar to the choices you face when purchasing a non-interchangeable-lens film camera. One similarity is economics: cameras with zoom lenses cost more than cameras with fixed-focal-length lenses. However, if most of the kinds of photographs you take are scenic travel images or those made with flash indoors, a lens with a focal length equivalent of 35mm may be all you really need. On the other hand, if you like to take portraits, you will need a lens with a longer focal length. The classic 35mm focal length for portraits is 85mm, although some people prefer 105mm. If you want to take photographs of your friends and family, look for a zoom lens that has at least an 85mm, or equivalent, focal length on its long size—longer equivalents are even better for use outdoors.

Top: Life's a beach. This classic photo shows the subjects slightly silhouetted against the sea.

Bottom: A more modern approach is slightly unfocused or what is referred to as a "painterly" depiction.

Right: On the Monet. Taking image manipulation even further, the picture takes on Impressionistic qualities. This was achieved by color addition and image-editing techniques.

Tip: 35mm equivalents?
Most photographers are familiar with the concept that a "normal" lens—the one that produces an image in the viewfinder that is similar to what you see with your eyes—is equal to the diagonal distance of the film size. For 35mm film, this is generally acknowledged to be about 50mm, although it is mathematically somewhat less in reality. The format of the CCD imaging chips found in digital cameras is often a different size and shape than the standard 24x36mm format of 35mm film. This has led most camera manufacturers to provide a 35mm-equivalent focal length for the lenses on their cameras. Instead of stating that a lens has a 9mm focal length, they will state it has an equivalent of 45mm. The same is true for zoom lenses, which are stated in terms of their 35mm equivalents instead of their actual focal length.

Avoiding backlighting

One of the biggest problems facing digital camera owners is flare caused by light striking the front element of the lens. This is worse for cameras with zoom lenses because there are more elements in the lens for light to ricochet around, and it can be a real problem. In addition to the actual flare reflection that shows up in the image, flare causes an overall lowering of contrast. Under these lighting conditions, many auto-exposure digital cameras will expose for the background, consequently underexposing the subject. But while you can eliminate problems with flare by only photographing scenes lit from the front, you will be missing the ability to produce some dramatic images lit from the back. Here are a few tips to overcome flare:

Run a test: Not all digital cameras handle flare in the same way. For some, the effect is similar to the way a film camera would handle this kind of lighting situation. The only way to find out what your camera will do is to shoot a few test exposures. You won't have to spend the time and the money for film and processing that you would if you were testing a film camera. If you have a zoom lens, set it at the widest setting and shoot toward the sun, trying to keep the sun on the outside edge of the frame. This is one area where digital cameras that use a single-lens-reflex (SLR) design have an advantage over those that use a separate viewfinder. Nevertheless, if your digital camera allows you to view through the LCD preview screen, use it to see the effect of flare and make an exposure or two. Then turn left or right slightly until the flare disappears from the viewfinder or LCD screen and make a second exposure. Evaluate the images on screen or, better yet, print them and evaluate the results of how flare affects your images.

Change camera position: Sometimes all you need to do to eliminate flare is to rotate your body—and the camera—slightly or make a slight change in camera position. Your test will help show you how sensitive your particular digital camera is to lens flare, so you'll know whether you even have a sporting chance of capturing an image under such lighting conditions.

Use a lens hood: Many digital cameras have a threaded front element that allows accessories to be installed. If so, buy a lens hood from your local photo retailer. Make it a practice to use a lens hood at all times to reduce flare. If you can't attach a lens hood, you can use the hot shoe (if you have one) to mount another useful accessory—the inexpensive Gran View Flare Buster. It slips into the shoe and features an adjustable stalk that lets you shade the lens to eliminate flare.

Use fill flash: One of the best ways to tame backlighting when photographing people is to use the camera's built-in flash. Some cameras have "fill" modes; that would be the best choice. Other cameras offer an "off" or "on" mode for the built-in flash, and you will be surprised how good the results are in backlighting conditions if the flash is just set for "on." There's more about using flash photography in the next section.

The latest trend in digital cameras is to provide more manual control. Cameras in the $1000 price range are offering "real" camera features, such as manual exposure control, bracketing, hot shoes, and traditional flash connections.

All of the momentum for providing manual control has a single goal: to provide more control over how your final image looks. All digital point-and-shoot and field cameras offer some type of automatic exposure, and in most cases, these systems provide accurate exposure. However, they can fail in situations where lighting is at its most dramatic, such as in back- and sidelighting. If digital cameras are to capture the same kind of images as film-based models, they need to be capable of controlling the amount of light hitting the imaging sensor under these kinds of lighting conditions. One of the most common exposure problems for digital cameras occurs during backlighting. Some people, burned by underexposed photographs, even stop shooting backlit digital images. They move the subjects so they are lit from the front, resulting in flat, boring lighting.

A better solution is to use the camera's manual controls to add exposure to the image. Digicams with manual control put exposure decisions back into the hands and mind of the photographer. Some cameras have only a few manually controlled apertures but a wide range of shutter speed choices. Other digital cameras provide full manual control over aperture and shutter speeds that you would expect to find on a film-based SLR.

Average, matrix, and spot

Light has two major components: quantity and quality. The quantity of light is important, because if not enough light hits the CCD sensor, the image will be underexposed. Too much light results in an overexposed image. Just as with film-based cameras, the best-looking digital images are those made at the proper exposure. The quality of lighting is just as important and is the one characteristic that separates truly great photographs—digital or otherwise—from merely average ones.

Most digicams use the averaging metering method that makes an exposure based on an average of all of the lighting conditions within a scene. Another system, sometimes called matrix metering, uses a median and mean statistical approach by measuring specific points in the camera's viewfinder, then comparing them with its

Manual control

database of lighting situations to determine the proper exposure. Spot-metering systems measure a tiny, usually one-degree section of the camera's viewfinder, which can be especially useful in backlighting situations. Most point-and-shoot models use some kind of averaging metering system, a few use matrix metering, and even less use spot metering. I expect this situation to change, first with multimode metering systems at the high end, later filtering down to the mid-priced models.

Top: Sharing secrets. The secret behind the success of these two images is imaginative lighting.

Bottom: By changing the direction of the light source, deeper shadows appear in the second photograph.

External flash units

Another way to control both the quantity and quality of light is to use external flash units. Some digicams are emulating film-based models by including a hot shoe connection. They are "hot" because an electrical signal is sent from the shutter circuit to trip the flash, and they're "shoes" because they offer a receptacle for connecting a portable electronic flash unit that can provide higher light output than the often puny built-in flashes found in most digital cameras. That doesn't mean these small, pop-up flash units are useless—far from it. They make an excellent source of fill-in flash when photographing people outdoors if you are not too far from your subject. The use of shoe-mounted flashes is valuable in situations where you need to photograph a large group of people indoors, or when you're far away from your subject and need more light than the built-in flash can produce. All flash units, built-in or otherwise, have a maximum working distance. I recommend that you take the time to read this specification before doing any kind of flash photography.

There is a trend for cameras to include a PC connection, allowing cables from studio flash units to be directly connected to the camera. When the shutter is tripped, a signal is sent along that cable to fire a studio flash. In addition to the ability to control both quantity and quality of the light, studio flash units provide an almost infinite control over the character of the light. If you don't have a PC connection but have a hot shoe, you can still use studio flashes by using a hot shoe-mounted accessory that has a connection. Hot shoe adapters are available from 35mm film camera makers such as Canon, Minolta, and Nikon, as well as from photo accessory companies such as Hama. Your digicam's hot shoe can also be used to connect wireless controls for tripping studio flashes. The best-known hot shoe-mounted wireless controls for tripping studio flashes are the We in units.

Flash

Above: In hot pursuit. Outdoor images can be picture perfect with the use of an external flash unit.

PC: Politically correct or what? I once walked into a camera shop—not a computer store—in Dallas and asked if they had any PC cords. "What do you want to connect your computer to?" was the reply. My response, that I wanted to connect my camera to a studio flash unit, was met with stunned silence. Even in camera stores these days, it seems that people have forgotten some photographic basics. "PC" is an acronym for Prontor-Compur, the two European shutter makers who long ago devised a system that allowed a cable from a studio electronic flash unit to synchronize with a camera shutter. Synchronization is critical, because the electronic flash—which has a brief duration—must fire during the time the shutter is open. A PC connection is found on almost all 35mm SLRs and all professional cameras, even though many pros now use some kind of radio or wireless control instead of cords to trip their studio flash units.

05 Digital film

Digital film. It's not just another computer industry buzzword for small, removable media devices. After all, you stick them in a digital camera, and when you make photographs, these tiny devices store the images. What else are you going to call them? Let's call them what they really are: digital film.

Thumbnail

Unlike "real" film—whose photochemical nature imparts a unique personality to each captured image by affecting color, contrast, and grain structure—digital film is simply a storage media. All of these imaging characteristics typically produced by film are created by a digicam's imaging chip, and, in this situation, digital film simply stores images. In that respect, digital film devices may be considered somewhat generic

in nature. What differentiates them is their format and storage capacity. Right now, digital film is available in several different formats that range in application as well as popularity.

Nevertheless, they all have characteristics similar to "traditional" film. Some are small enough to fit into your shirt pocket, much like a roll of film, and when a storage card is filled with images, you can slip another one into a camera just as you

would change a roll of film. Larger capacity cards allow storage of more images but also cost more. Best of all, although these cards may vary in capacity and price, any camera that accepts a specific format can use one of any capacity, much as a 35mm camera accepts film in 24- or 36-exposure lengths.

For computer realists—call me a cynic if you wish—it's beyond imagining that camera manufacturers would have, early on, standardized a single removable media format for storing digital images. Instead they've adopted several different formats, and instead of keeping the number small, newer formats have proliferated. Here are the big four.

PC cards: Like many digital film formats, PC cards have had many name changes. Originally called PCMCIA (Personal Computer Memory Card International Association) cards, they were the standard for removable image storage long before the "digital film" moniter was coined. PC cards are available in many formats, including ATA Flash for storing images. ATA Flash cards connect through a standard ATA (Advanced Technology Attachment) interface that's similar to the one used for connecting hard disks. They are, in fact, the solid-state equivalent of a hard disk. Digital film PC cards have memory capacities as high as 1GB, making them ideal for field cameras that create large image file sizes. Muddying the format waters even more are Type 1, Type II, and Type III versions that provide variations in thickness for each type of device. More information about this format can be found at www.pc-card.com.

Compact flash: First introduced by SanDisk in 1994, these matchbook-sized memory cards are pin-compatible with PC cards. This makes it possible for companies to offer PC card adapters that allow CompactFlash media to be used in cameras originally designed only for PC cards. For a time, Kodak called its version of CompactFlash cards "Picture Cards," but now most people refer to the format simply as "CF." Initially offered in small sizes such as 2MB, CompactFlash cards are now available in sizes up to 128MB, with a 320MB Type II (5mm thick) card available from Simple Technology.

Digital film formats

IBM's Microdrive mini-hard disk could be considered a subset of this format. The Microdrive's form factor is identical to Type II CompactFlash and is available in 170MB or 340MB capacities. (Since CompactFlash is so similar to PC cards, the thickness types that are used with that format may be found here, too.) Microtech offers Microdrive models in 170MB or 340MB capacities with or without a bundled PC card adapter. More information about this format can be found at www.compactflash.org.

SmartMedia: Toshiba's Solid-State Floppy Disk Card (SSFDC), usually called SmartMedia, is a flash memory-based storage card designed specifically for digital cameras. The tiny SmartMedia card combines a flash memory chip with a 22-pin surface connector in a tiny 45x37mm package (about the size of a cracker). Because of this simplicity, prices for SmartMedia are less than for other types of memory cards. An adapter allows SmartMedia cards to be used in devices that use PC cards, but by far the most impressive adapter is FlashPath, which allows images stored on SmartMedia cards to be read by almost any Mac OS or Windows computer's floppy disk drive. SmartMedia cards are available in 8MB, 16MB, 32MB, and 64MB sizes.

Clik!: Iomega's new 40MB Clik! disk uses disk-like technology instead of solid-state flash memory to produce a low-cost, high-capacity alternative to CompactFlash and SmartMedia. A 40MB Clik! disk is so small that it will fit inside a slot in a 35mm slide storage page and, when purchased in a ten-pack, costs under ten dollars each. I can't help wondering if the so-called "click of death" syndrome (http://grc.com/clickdeath.htm) that plagues Iomega's Zip and Jaz cartridges will be a problem for Clik! More information about this format can be found at www.iomega.com/clik/index.com.

Digital film formats

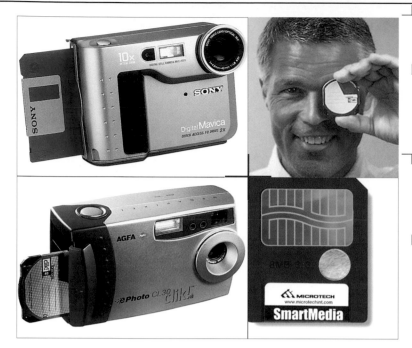

Top left: Sony's Digital Mavica cameras use a conventional floppy disk as a form of digital film.

Top right: Iomega's Clik! disk offers a different take on digital film by using rewritable magnetic media instead of solid-state materials like its competitors.

Bottom left: Agfa was the first to make a digital camera with a built-in Clik! drive, providing storage for up to 360 images, depending on resolution choices.

Bottom right: Tiny SmartMedia memory cards pack lots of space into a device that seems too small to actually work, but work they do, providing the most compact form of digital media—so far, anyway.

Left: Take the plunge. There are numerous ways to transfer your images from your camera to your computer.

Right: Off the wall. These digital download options will vary in speed, convenience, and ease of use.

Digital film readers

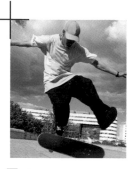

Top: Balancing act. When deciding on the type of adapter to purchase, remember the type of hard drive you have and the format of transfer —CD or floppy disk.

There seem to be as many ways to transfer image data from digital film to computers as there are media formats. While most cameras allow direct downloading of images from the media inside the cameras using serial, USB, and even FireWire connections, I recognize that this may not be the most convenient or quickest method for capturing images. One of the simplest ways of downloading images is by using the FlashPath adapters for SmartMedia that Delkin, Fuji, Olympus, and others offer, providing access via the lowly floppy drive. While the floppy drive may seem universal,owners of iMac and Power Macintosh G3 or G4 machines know you can't take that situation for granted. While FlashPath is Mac OS-compatible, it's not compatible with some USB add-on floppy drives, such as Imation's SuperDisk. Users of digital film other than SmartMedia and some Mac OS users will need to look elsewhere for help.

The following brief look at card readers is not intended to be a complete round-up of every product available but will provide an overview of the types and prices of typical digital film readers.

PC card: Because it minimizes desktop clutter, I've always favored built-in drives to add-ons. This is why Simple Technology's SimpleStation appeals to me. This drive is an internal PC Card reader that works with any Type I, II, or III PC card or adapter that holds other media. This digital film "drive" has two sockets that simultaneously accept

either two Type II cards or a single Type III (10.5mm) card. Cards are hot-swappable, which means that you can pull out one PC card and plug in another without restarting your computer. As part of its Film series, Delkin Devices offers an ISA-based internal card reader that works with TypePC cards.

Compact Flash: Microtech's CameraMate is an external USB-based device that offers slots for both CompactFlash and SmartMedia digital film. The sleek-looking reader that features Mac G3 complementary styling is also compatible with IBM's Microdrive format. Simple Technology offers parallel port and USB PhotoReaders for CompactFlash media that cost less than $100. SanDisk's ImageMate CF reader is available in parallel port or USB versions.

SmartMedia: Delkin Devices offers Film Readers in many formats, including a USB SmartMedia device that loads images into your computer at speeds twenty times faster than a serial connection. Simple Technology offers a SmartMedia PhotoReader that uses a parallel port connection. Antec's PhotoChute 3 is a USB device that reads CompactFlash, SmartMedia, and Type I and II PC cards.

Clik!: Iomega offers the handheld Clik! Drive Plus that lets you download photos from your digital camera and has a PC card connection.

One of the reasons that the 35mm film format remains popular after almost seventy years is that the media it uses is ubiquitous. It is so easy to buy a roll of film to fit the many models and brands of 35mm cameras. This is not true with digital cameras.

I think that the lack of a single, standard storage media has had a negative impact on the wider acceptance of digital cameras. It would be better for consumers if the companies involved would get together and settle on a standard instead of yet another "Beta versus VHS" war, but that does not appear to be the case.

Matsushita, SanDisk, and Toshiba have proposed a memory card format called Secure Digital (SD). This postage stamp-sized card is built around encryption concepts borrowed from DVD audio and is designed for high-capacity storage. Other new digital film formats surface from time to time. Sony's Memory Stick is another shot at producing a standard that's incompatible outside of Sony's own world of digital products.

Because of this confusion, some camera companies are hedging their bets with a dual-slot configuration that allows for the use of both CompactFlash and SmartMedia. Images can be stored in either media and even copied from SmartMedia to CompactFlash. Similarly, multifunction card readers will be required by digital imagers until a single standard—or even two— wins the digital film format war.

Toward the future

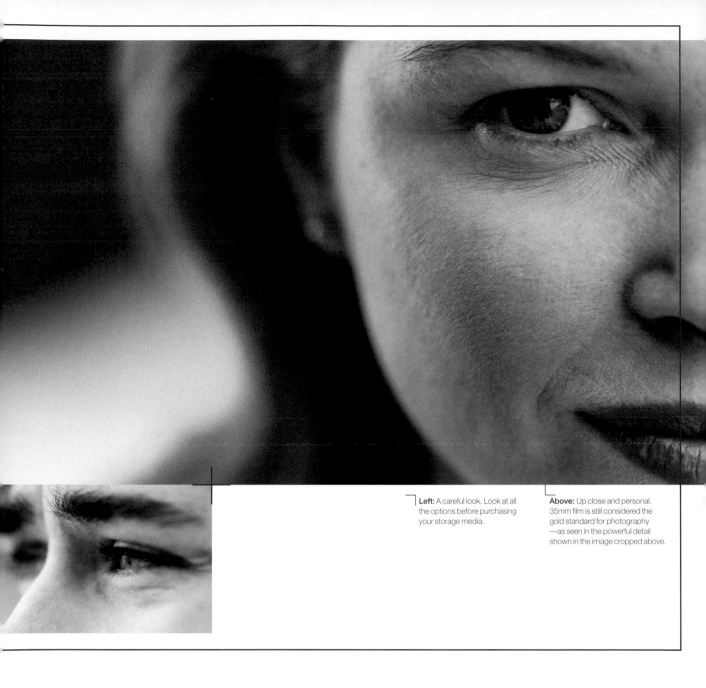

Left: A careful look. Look at all the options before purchasing your storage media.

Above: Up close and personal. 35mm film is still considered the gold standard for photography —as seen in the powerful detail shown in the image cropped above.

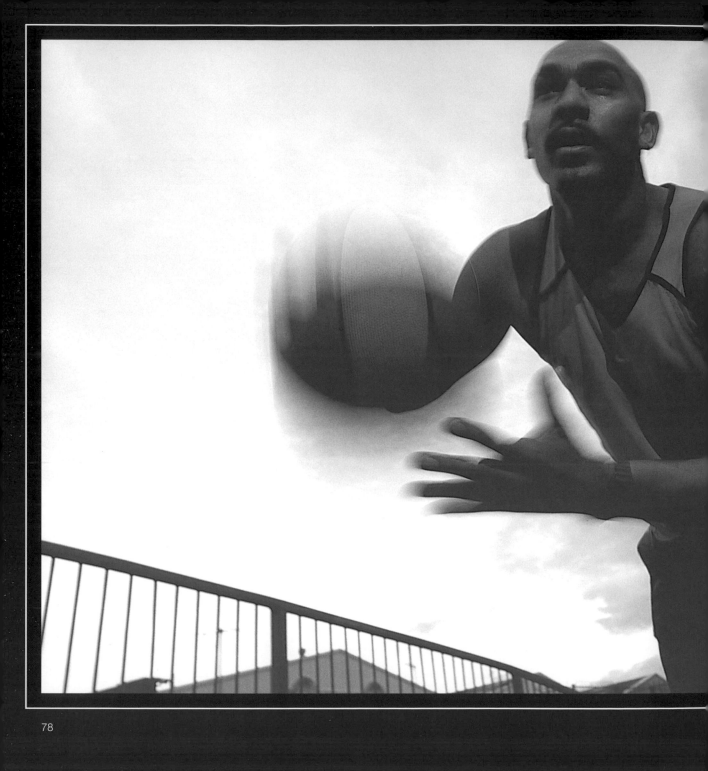

Maximizing your digital camera's capabilities

Digital still cameras are fast replacing their silver-based equivalents in the pockets, purses, and gadget bags of shutterbugs all around the world, and it's easy to see why. Digital still cameras have a natural element of fun about them. There's no film to buy and no trips to the local one-hour photo lab to wait and then pay for color prints. The limitations of affordable chip-based photography mean that not all of your digital images are ready to hang in a gallery or on the refrigerator door. You can improve the quality of your digital photographs by using the following tips, tools, and techniques.

What makes a good digital image? The same things that make a good traditional photograph: the image should be acceptably sharp where it should be sharp; it should have a pleasing composition; and the exposure should be good. Some "rules of thumb" about what makes a good digital photograph are the same as for silver-based imagery, but since many digicam users come from the world of computers and not photography, a brief review won't hurt. The most important rule to remember is that a good image is one that you like. The most important audience you have to please is yourself. If you like the photographs, then they're good enough.

Get closer: When taking a photograph, especially of a person, don't be afraid to move in closer. The easiest way to improve any digital image is to get closer to your subject. While a zoom lens will get you visually closer to your subject, not all digital cameras have zooms. Some cameras offer a digital zoom feature that crops part of the original scene, creating a larger image with less resolution. Instead, try this experiment: make an exposure of a scene or person the way you normally would. Next, take just one step closer to your subject, recompose the shot, and then capture the image. Compare the two photographs and ask yourself which one you like best. I'll bet that you like the closer one much better. Next time, take two steps closer and see what happens.

Watch the horizon line: There's no doubt that many fashionable or otherwise trendy photographs are created with horizons tilting in all sorts of odd directions, but that style may not be appropriate for most of your images. If a horizon line appears in a photograph, taking the time to make it parallel with the photograph will help prevent its viewers from getting seasick.

Watch the background: There's an old photographic axiom: "If you take care of the background, the foreground will take care of itself." Telephone poles don't mysteriously appear behind a person's head after you make the photograph. They were there all

Rules of thumb

the time, you just didn't see them. Before snapping the shutter, take one second to look at the background; you'll be surprised to see what's lurking back there. Then, if needed, change your camera position or the focal length of your zoom lens.

Shoot vertical images of a single person:
While groups are inherently horizontal (landscape) images, most, but not all, portraits of an individual work best as verticals. This rule of thumb, combined with getting closer to your subject, can create more dramatic portraits by eliminating distracting background elements.

Make images at something other than eye level:
When you are serious about making images, it's always a good idea to wear clothes that you don't mind getting a little dirty. Kneel down on the ground, climb a ladder, lie on your stomach to give your images a new perspective. Since most photographs are made at eye level, yours will stand out from the pack.

Use a tripod: Most digital cameras have a tripod socket, and if you want to extract the maximum sharpness out of your camera's lens, use a tripod. You don't even need to spend a lot of money. You can purchase one at a used-photo-equipment store. Just make sure that the tripod is solid and steady.

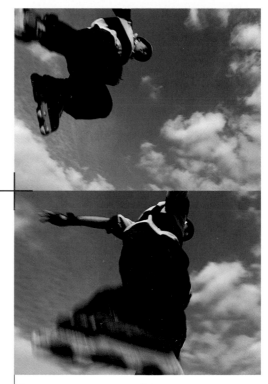

Top: Power of perspective. The horizon line tilts in what is considered a "trendy" angle in this sports image taken by a fashion photographer.

Below: Motion blurs and color correction (in this case, added blue) are frequently seen in contemporary outdoor images.

A digital solution

A digital solution?
If you forget to take advantage of the above rules of thumb, some problems can be fixed in the digital darkroom by using tools provided in image-editing programs. Here are a few tips on how to digitally eliminate some common mistakes.

Crop: One of the ways you can improve an image that was made when you were not as close to your subject as you might have liked is to use the Crop tool found in most image-editing programs. The Crop tool can be used to improve the impact and composition of a digital image, but it's not without some cost: reducing the size of the image in pixels ultimately lowers the quality of that image. Some digital cameras offer this same feature as a "digital zoom." What these cameras typically do is crop the image in the camera for you, resulting in the same lowered quality. However, even an image with lower quality is better than no image at all.

Rotate: The Rotate command can fix all of those slightly tilted horizons that affect even the best photographer's work. Your image can be rotated by even fractions of a degree, allowing you to get the horizon line—or edge of a building, for that matter—to be as straight as you want it to be. Since the entire image will be rotated during this process, some minimal cropping will be required to "square off" the corners to give the image its original shape. You can even cheat a bit here by setting the cropping parameters to be the exact size of your original image. You end up enlarging the image slightly—sometimes called resampling—but maintain your original image size.

Sharpen: Photographs can be critically sharp, acceptably sharp, or not sharp at all. One digital technique that has no equivalent in traditional photography is the ability to sharpen an image. The Sharpen command that is found in most image-editing programs typically accomplishes this by increasing contrast, which is sometimes enough to make an image acceptably sharp. The Unsharp Mask technique introduced in chapter 2 can help images that were scanned or digitized in a less-than-sharp manner.

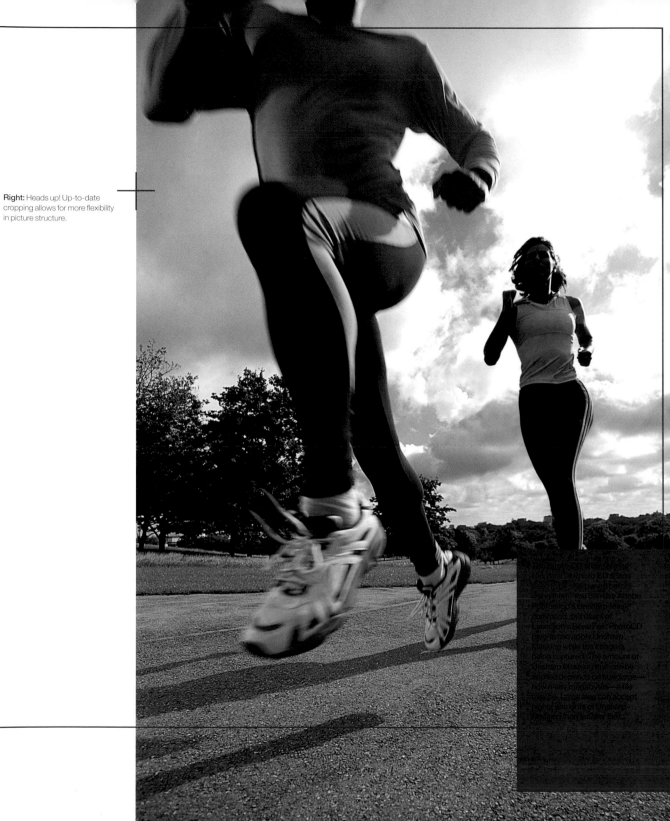

Right: Heads up! Up-to-date cropping allows for more flexibility in picture structure.

Here is picture-taking advice that applies directly to capturing images digitally.

Tip 1: Try to avoid backlighting situations.

When making a photograph of a person standing in front of a window, for example, the camera's built-in meter reads the light passing through the window and around your subject and exposes for the window—not the subject. This ends up producing a silhouette-like image that's difficult to correct with any kind of image-manipulation software. In this situation, set your camera's built-in flash to "Fill Flash," or just make sure it's turned on. Since not all digital cameras have built-in flashes, the next best alternative is to change your camera position. Place your subject so that light from the window falls onto the face, and position yourself so the window will not be visible in the final image. This way, the camera will measure the light falling on the subject and apply the proper exposure settings.

Tip 2: Edit images in-camera.

The smaller the amount of compression, the larger the file. This means the camera's storage media can hold fewer pictures. From time to time, take a break from shooting and review your images using the camera's standard or optional LCD preview screen. The truth for most of us is that not every photo we shoot is a masterpiece, so use the camera's Delete or Erase button to remove less-than-perfect images. Editing images and eliminating rejects can triple or quadruple the number of images your camera's digital film can store.

Tip 3: Bring extra batteries.

Digital cameras eat batteries, and without power, you won't be able to take any pictures. The rechargeable NiCad (nickel cadmium) batteries many cameras use do not have the longer life of the NiMH (nickel metal hydride) batteries used by others. LCD preview screens, while convenient and fun, will chew up batteries fast, so it's a good idea to have a fresh pack of your favorite alkaline batteries along just in case. Some cameras, especially those with lithium ion batteries, don't accept traditional alkaline batteries, so either bring along the charger or have an extra recharged battery available. While on the subject of batteries, give some preference to those cameras that use lithium ion batteries. They are the longest lasting of the current crop of batteries being used for digital cameras.

Tips on how to improve your digital images

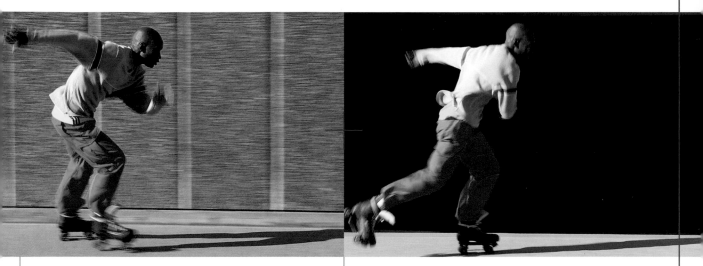

Left: Rockin' and rollin'. Vivid colors contrast against a grey background in this sports shot.

Right: More contrast. To intensify this color contrast, the background has been color manipulated to black for even greater effect.

Tip 4: Watch the speed limit. All imaging chips have an ISO film speed equivalent, and you should know what it is. When shot under low-light conditions, a camera with an ISO equivalent of 100 will produce a noisy, unusable image. If you have a built-in flash, use it when working indoors. Cameras with modest light-sensitivity capabilities and no built-in flash should only be used outdoors. There is a trend in digital point-and-shoot cameras to include a hot shoe for an accessory flash, and for some cameras, dedicated flash units are available, much like a film-based camera.

Tip 5: Protect your lens. While film-based cameras often provide lens caps or some form of lens protection, not all digital cameras offer similar features. When carrying a digital camera, be sure to use a case or lens cap to protect the front element of the lens.

Tip 6: Avoid CEV syndrome. Photofinishers tell me that they often see film with images from Christmas, Easter, and vacation—all on the same roll. Don't make the same kind of mistake with your digital camera. After shooting photographs, transfer all of the files onto your computer's hard disk to free up your camera's memory. As you collect more and more images, you might consider saving the images onto some form of removable media, such as Iomega's Zip or even CD-recordable disks. Both kinds of drives are becoming less and less expensive, and you can even order computers with built-in Zip drives. By storing your images somewhere else, your camera is ready to record those special moments, such as when Junior takes his first steps.

Tip 7: Accessorize. Digital cameras can have a sensitivity to infrared light that can cause color shifts in the finished image. In addition, some chips have a slight cyan bias, while others seem slightly magenta. While you can always correct these conditions using an image-enhancement program, it's better to capture images the right way. Tiffen's Hot Mirror filter can correct many of these problems by reflecting most of the infrared light away from the imaging chip. Another common problem from digital cameras is a pale skin tone. This can be corrected by using a Tiffen 812® warming filter that makes skin tones look natural.

Tip 8: Back up, back up, and back up. This is always good advice for computer users, but digital camera owners should take heed as well. Although digital cameras are dependable, any electronic device can fail. When photographing important events, such as your daughter's first dance recital, bring along a one-time-use film camera containing high-speed film—just in case. You can always have the images converted digitally onto a Kodak Picture CD when the film is processed.

Tips on how to improve your digital images

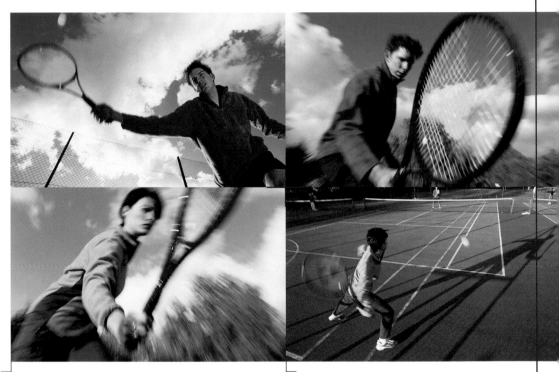

Above left: Go on, give it your best shot. And if it's not… then delete. That's one of the pleasures of working with a digital camera.

Above right: 40-Love. Don't give up if your images appear too cyan or magenta. Products like Tiffen's Hot Mirror filter can correct many of these problems.

Below left: What a racket. Special effects like Adobe Photoshop's motion blur transform images from the mundane to the supercharged.

Below right: Go long… to protect your lens. Be sure to carry a case or lens cap.

07 Digitizing with scanners

While there are several different methods to capture digital images, scanners may be the most practical if you're a beginning digital imager, because they allow you to create computer-ready images using the same cameras and film you're already working with. What's more, scanners can be used to digitize all of the images from your existing library of photographs.

There was a time not so long ago when scanners were so expensive that only large advertising agencies and service bureaus could afford them. Now scanners are available in a wide range of prices that can fit everyone's budget, from the casual snapshooter's to the professional photographer's.

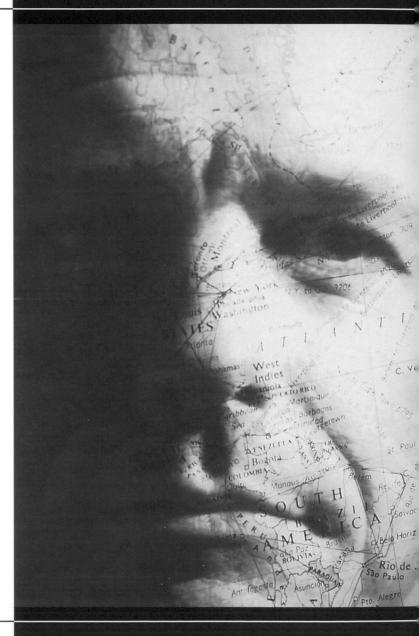

Scanners convert photographic images into digital form by passing a light-emitting element across an original photograph, transforming it into a collection of pixels that are stored as a digital file.

The first scanning devices used in the publishing industry were drum scanners. This type of scanner focuses a light source onto an original transparency that is mounted on a rotating drum. Before entering photomultiplier tubes (PMTs), light is directed onto mirrors and then through red, green, and blue filters that act as optical amplifiers. Analog-to-digital converters (ADCs) change the analog voltages coming from the PMTs into digital form. This technology is capable of handling a wide range of image densities and produces high-quality output, but that complexity also makes drum scanners expensive.

Differences abound in scanners, and all scanners won't produce identical results, even if the base specifications seem similar. Inexpensive desktop scanners also use a lens to produce a digitized image, but just as all camera lenses are not the same, the lenses and sensors found in different scanners are not all the same. In addition, just as with some inexpensive cameras, some low-priced scanners use plastic lenses or inexpensive glass lenses.

Behind that lens is an image sensor—more often than not a CCD (charge-coupled device)—that converts light reflected off the original print into an electrical signal. The typical desktop scanner uses a CCD array consisting of several thousand CCD elements arranged in a row on a single chip. Three-pass CCD scanners—those that make three passes across an image to digitize it—use a single linear array and rotate a red, green, and blue (RGB) color wheel in front of the lens before each of the passes is made. Most single-pass scanners use three linear arrays, which are individually coated to filter red, green, and blue light. The same image data is focused onto each array simultaneously.

As in a drum scanner, an analog-to-digital converter changes these signals into digital form. The analog-to-digital converters found in scanners are rated by their color depth. An 8-bit ADC, for example, separates all of the visual information into 256 brightness levels, while a 10-bit unit converts the identical signal into 1024 levels. A 12-bit ADC produces 4096 levels. Since there are sensors for red, green, and blue, the ADC behind each one allows the scanner to produce 24-, 30-, and 36-bit scans. The quality of the ADC can affect the ultimate quality of the digital image. Some scanners use contact image sensors (CISs), which bounce light off the surface of a print directly onto a closely mounted sensor, allowing these kinds of scanners to be more compact than those using CCDs.

Above: A light source, like the one added digitally to the background above, gives more contrast to the subject—without causing a silhouette effect.

Right: True close-ups with tight cropping are modern compositional themes.

Scanning the horizon

Making comparisons

Left: Urban pleasures. An evening game of soccer benefits from a digitally enhanced sky and field.

Bottom left: A close one. Look closely at this image—natural, wouldn't you say? Actually, it is made of three images comped together—the goalpost, the ball, and even the goalie!

Bottom right: You've been framed. The goal here is both the central focus and acts as a visual frame.

Comparisons of scanners can be based on their color depth, resolution, and dynamic range specifications. Resolution for scanners is often specified by both optical as well as interpolated (or "enhanced") resolution.

Color depth: Popularly priced color scanners range from 24- to 36-bit versions, with professional-quality models providing greater color depth. The more bits you have for each color, the more realistic the final scanned image will appear. Most 24-bit scanners are inexpensive (some even under $100), but the higher-bit scanners are more expensive.

Resolution: A scanner's resolution is determined by the maximum number of dots or pixels per inch it can digitize. If a scanner uses a 2550-dot sensor to scan an 8.5-inch width, it has a resolution of 300 dpi. In theory, a resolution of 300 dpi means a scanner can resolve details up to 1/300 of an inch in the original image. Originally, popularly priced scanners were only available in resolutions of 300x300 dpi or 600x600 dpi, but as scanner manufacturers improved their precision and processing capabilities, the vertical resolution began to increase. Some scanners advertise two resolutions, one for horizontal and one for vertical, such as 300x600. To produce a 300x600-dpi scanner, the scanner only needs to change a set of gears in order to move in 1/600- or 1/1200-inch increments in the vertical direction (back to front). When 1200 dpi or greater is selected, this process slows down the scanner somewhat, and it may pick up more detail in the vertical direction.

Dynamic range: A scanner's dynamic range measures how wide a range of tones the scanner can record and is based on a combination of the maximum optical density that can be achieved by the hardware and the total number of bits that can be captured. Some manufacturers refer to dynamic range as "dMax," much like the film term, and there are similarities in how it's measured practically. (In photographic terms, "dMin" is the brightest possible level and "dMax" represents the darkest possible level for the same image.) Dynamic range can be interpreted as the range of f-stops that can be captured from a print or slide; it is rated on a narrow scale from 0 to 4.

For techies only:
More on dynamic range
Dynamic range, or image density, is a measurement of image brightness made using an optical densitometer that has a scale ranging from 0 to 4, where 0 is pure white and 4.0 is pure black. Photographers may recognize that these are the zones that Ansel Adams called 0 and 10. Less brightness means more density. Image density is measured on a logarithmic scale,

and a measurement of 3.0 is actually 10 times greater than a value of 2.0. The values of density capable of being captured by a specific scanner are sometimes called dMax and dMin. If a scanner's dMin were 0.1 and its dMax were 3.2, its dynamic range would be rated at 3.1. Higher dynamic range shows greater image detail in the shadow areas of a photograph. To put it all in perspective, a photograph reproduced in a typical magazine

has a dynamic range of less than 2.0, and some photographic color prints can have a rating of 2.0. Film negatives might have a range near 2.8, while slides may go well over 3.2.

Types of scanners

Scanners are available in several basic types, with a few variations on those themes.

Handheld scanners: These make you do all of the work of digitizing an image by physically rolling the scanning element across the face of an original print. Handheld scanners have the advantage of being inexpensive, but the disadvantage of being limited by the width of the scanner's head. Some hand scanners include software that allows you to "stitch" separate scans together. How well this process works depends more on the steadiness of your scan than the software. Hand scanners formerly were the most popular type of scanner available, but as the price of desktop scanners dropped, their popularity rapidly decreased. As this trend continues, I expect the category to disappear and be replaced by the snapshot scanner.

Snapshot scanners: A variation of the kind of document scanners that use a sheetfed method to scan letters and forms for optical character recognition (OCR) purposes, this newest class of scanner is a compact desktop device that's specifically designed to scan snapshot-sized photographs. You insert a print, press a button, and the snapshot is scanned!

Flatbed scanners: These units look like small copy machines, and, in fact, there are similarities in how they work. The biggest problem is the sheer number of different flatbed scanners available, making the choice of which one to purchase bewildering. Shopping for a flatbed scanner is a matter of setting your goals for the type of images you will be starting with, along with what form your output will take. First ask yourself what the maximum size of your original image is. This tells you how big the glass-top scanning area must be. Next, ask what the resolution of your output will be. For the best output, make sure that the resolution of the scanner exceeds that of your output device.

Multifunction peripherals (MFPs): This is one category that is growing in popularity. Companies such as Canon, Epson, and Hewlett-Packard produce MFPs that combine faxing, printing, and scanning functions in a single desktop device. Both Canon and Alps Electronics offer a scanner head that turns their photo-quality printers into part-time scanners. If you only need to do occasional scans, any one of these MFP devices may be all you really need, but the serious pixographer will want to skip them.

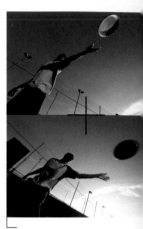

Top: A toss up. By tilting the horizon line, this image transforms from the banal to the fashionable.

Below: Flip you for it. The strength of the bottom image is its chaos of horizontal and bisecting lines.

Tip: Keep it clean
When scanning 35mm negatives, film scanners typically require that you use an enlarger-style carrier to hold the film strip. This brings up the biggest problem associated with film scanners: cleanliness. Keeping your negatives and slides clean is much more important with film scanners than with flatbed scanning. Even the smallest dust speck can end up looking like a giant boulder in the final scan.

Top left: Nowadays hand scanners are more likely to be found in used computer sales than in mail-order catalogs or retail stores.

Top right: Polaroid's SprintScan 4000 film scanner is so named because it can scan film at 4000 dpi. In addition to scanning slides, the SprintScan 4000 can scan 35mm negatives and Advanced Photo System film with an optional adapter.

Bottom left: Minolta's Dimâge Scan Elite film scanner has a maximum input resolution capability of 2820 dpi and a 3.6 dynamic range to ensure deep shadows and bright highlights.

Bottom right: Sheetfed scanners, like the Visioneer, are used in many businesses to scan documents. Their specifications are mostly oriented toward reading black on white text, so the quality of many sheetfed scanners is not good enough for photographs.

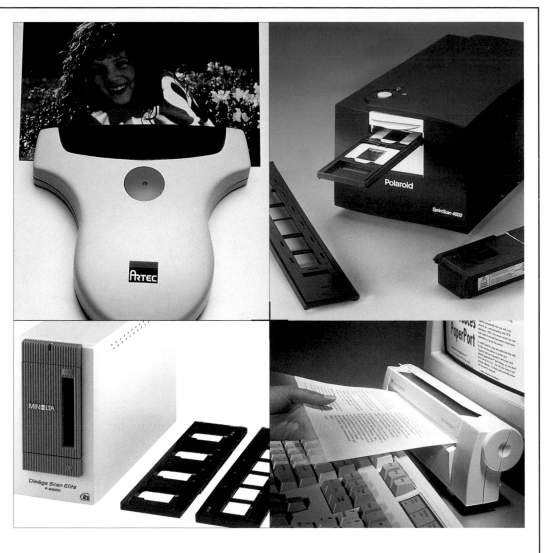

For many photographers, a flatbed scanner is the best solution, but film scanners allow you to scan negatives and transparencies. Film scanners are usually more compact than flatbeds, and their purchase cost reflects the different-sized film formats that they can digitize. For example, 35mm scanners are less expensive than those that can digitize medium-or large-format film. One reason film scanners are popular is that they eliminate a generation by scanning the original film; this removes the print phase from the process, and you save money and time. The typical slide scanner has a slot in the front panel for inserting a slide or a strip of negatives in a holder. When the scanner starts working, it grabs the slide and pulls it inside during the scanning process.

The features to look for in a film scanner are similar to those you would seek in a flatbed scanner. In addition, you will want to know what film formats it can scan. If you only shoot 35mm film or slides, you don't need to spend more money for a larger scanner that can handle sizes up to 4x5 sheet film. You'll also want to know the dynamic range of the scanner. Until recently, only the most expensive slide scanners (those that cost more than $6000) offered a dynamic range greater than 2.5; now more affordable scanners can produce images at 3.0 or higher.

You may hear recommendations that a scanner should have an optical resolution of 2700 dpi or more. That's because resolution requirements are much more critical for film than for prints. Given the small size of the original image, a higher-resolution scan is required to get the maximum quality out of the film. Having larger-resolution—and bigger—files also allows some flexibility if the image will be cropped. In addition, a 4000-dpi scan provides twice as many pixels and twice the detail of a 2700-dpi scan, all of which results in sharper, crisper images.

Do you need a film scanner?

There was a time when the only way you could digitize 35mm, roll film, or large-format film was by using a film scanner. As flatbed scanner prices dropped through the floor, manufacturers began looking for new functions to add value to their products. One of the first "new" features being touted by scanner companies is the ability to scan film in addition to prints.

Using flatbed scanners to digitize film is nothing new. Transparency adapters have been available for some time as an option for many flatbed scanners. In most cases, these adapters were nothing more than "lightbox" lids for the scanner and provided a method for backlighting negatives or transparencies so they could be digitized by the moving CCD element. This method always produced a digitized image, but the adapter was often cumbersome and always expensive—sometimes costing more than the scanner itself. Now that's changing. Transparency adapters have gone from being expensive to inexpensive and even standard equipment for some models.

Above: Does the image make the goal? Even with beautiful lighting, the awkward crop makes this image less than satisfactory.

Below: Landscape style cropping does work when the whole subject can be seen. Here, however, an emotive face still doesn't make up for the lower third being cast in dark shadows.

Film scanners

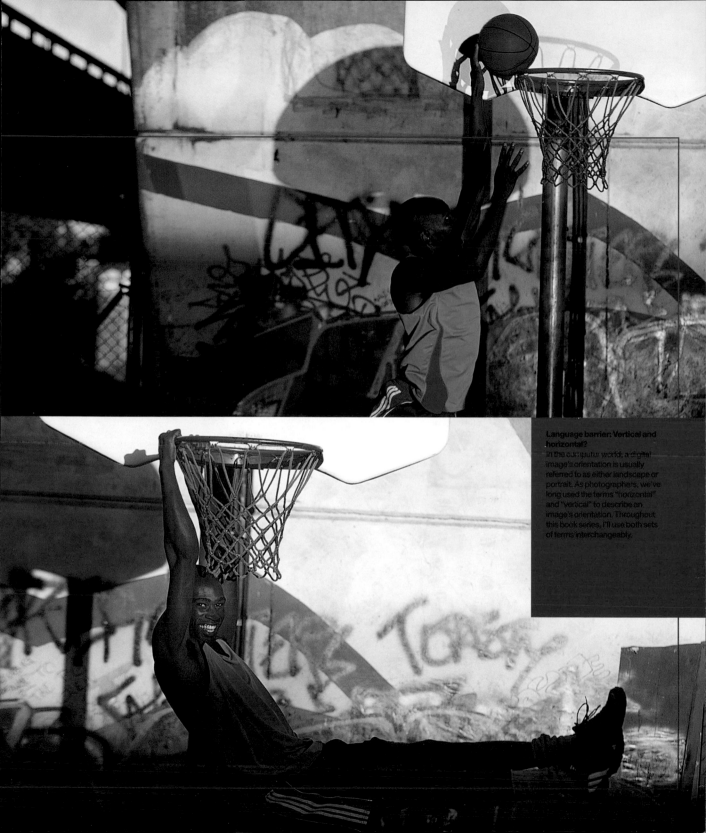

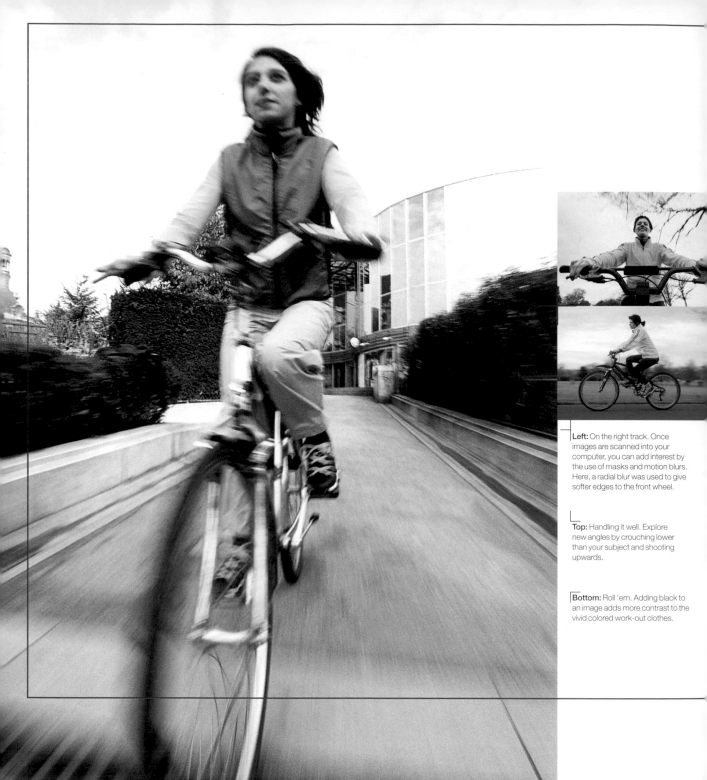

Left: On the right track. Once images are scanned into your computer, you can add interest by the use of masks and motion blurs. Here, a radial blur was used to give softer edges to the front wheel.

Top: Handling it well. Explore new angles by crouching lower than your subject and shooting upwards.

Bottom: Roll 'em. Adding black to an image adds more contrast to the vivid colored work-out clothes.

Software can make a difference

How well your scanner performs also depends on the scanning software you use. One of the most important developments in scanning technology was the development of the TWAIN standard. TWAIN devices allow compliant software to scan text or images directly from within an image-editing application.

Scanning software is packaged with all flatbed and film scanners, and manufacturers are guided by the goal of making the scanning process as simple as possible. Most scanner manufacturers bundle proprietary software to allow you to scan images with the least amount of muss and fuss. Agfa's ScanWise software, for example, scans originals perfectly and then inserts them directly into your chosen application, allowing you to scan directly to your word processor, image editor, Web browser, fax, or e-mail applications. Its auto-processing features will rotate misaligned originals and check to see if they're text, color, or black and white. The software's PhotoGenie feature enhances the detail and color balance of your original images.

Right: An example of a flatbed scanner and a color copier/printer.

There are three ways to connect a scanner to a computer. You can connect via SCSI (small computer standard interface), EPP (enhanced parallel port, often called "parallel"), or USB (Universal Serial Bus).

SCSI (pronounced "scuzzy") connections were formerly found on Mac OS computers. Parallel ports are still found on Windows computers, often being used to a printer connection. Most parallel port scanners have a "pass through" allowing you to connect your printer and the scanner. A few scanners, such as those from Epson, offer both SCSI and parallel port connections, allowing you to connect either a Mac OS or Windows computer. Right now the most popular standard is USB, which was designed to eliminate the cable clutter often found dangling out of the back of many computer systems. You can connect or disconnect a USB device while the computer and scanner are turned on and everything is "hot," something that spells disaster for a SCSI device. Mac OS and Windows 98 and its later versions support USB, and more and more companies are announcing USB-equipped scanners.

Above left: Camera ready. Black bisecting vertical lines make the image look like a string of moving footage. A usual approach to a static image.

Above right: Your man on the street. This shot was taken overhead to capture the parallel shadows of the runner and the telephone pole.

Connections and connectors

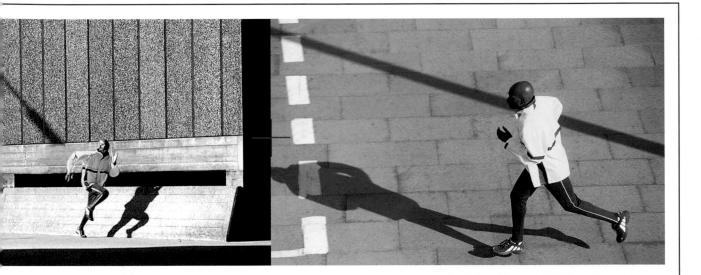

Tip: Cables make it possible
Make sure you use the best-quality cables you can afford when connecting a scanner to your computer. Don't trust your photographic data to the cables supplied with some scanners. Too often these cables are built to a price, not a standard. You should use a cable that eliminates cross talk, static, electromagnetic interference, or radio frequency interference. Other features to look for are double-shielded cables with low impedance wires and gold-plated copper connectors. While these kinds of cables cost a little more, ask yourself, are your images worth it?

If you don't want to invest in a scanner, you can have your existing slides and negatives digitized —scanned—by using those photographic labs, camera stores, or service bureaus that offer services using the Kodak Photo CD, Kodak Picture Disk, or Kodak Picture CD. In addition, many other companies and photo labs offer a digitizing option when you have your film processed. Instead of worrying about purchasing hardware and installing scanning software, you can let someone else do it.

08 Digitizing services

A hundred years ago, George Eastman coined the slogan "You push the button and we do the rest," and while much has changed in photography, that adage can now apply to the Kodak Photo CD process. All you have to do is take your exposed, unprocessed film to a photofinisher who will turn your photographs into digital images. If you turn in transparency film, you'll receive a box of slides along with a Photo CD containing all the images that are on the film. If you shoot negative film, you'll get a stack of prints along with the disk. Photo CD facilities can also digitize images from all of your existing color slides, as well as individual black-and-white or color negatives.

Let someone else do it

Top: People portraiture is often the most difficult to get right. The first step is to make the subject comfortable.

Bottom: Normal household objects, such as a mobile phone, are ideal props for impromptu images.

Right: As discussed earlier, eye contact is ideal in people portraiture. The image shown here is of a model who is showing relaxed body language.

In order to make a finished Photo CD, a photo lab or service bureau uses a Photo CD transfer station to convert your analog images into digital form using a high-resolution film scanner, a Sun SPARCstation computer, image-processing software, a disk writer, and a color thermal printer. During the digitizing process, every image is prescanned and displayed on a computer monitor. The operator checks the orientation (portrait or landscape) of the image, then makes a high-resolution scan. That scan is adjusted for color and density and compressed to 4.5MB using Kodak's proprietary file format before being written to the disk. A thermal printer creates an index sheet showing all of the images that were digitized, and this sheet is inserted into the cover of the CD case.

A Kodak Photo CD master disk is designed for 35mm film, and each disk can hold 100 images. The images are digitized at five different resolutions using a format that Kodak calls Image Pac. That's why you'll often hear such scans described as "five res" scans. On a Photo CD master disk, you will find the five image files at these resolutions:

Base/16: 128x192 pixels
Base/4: 256x 348 pixels
Base: 512x768 pixels
Base*4: 1024x1536 pixels
Base*16: 2048x3072 pixels

Another version of the Photo CD master disk is the Kodak Pro Photo CD. In addition to 35mm film, Pro Photo CDs accept 120 rolls as well as 4x5 sheet film and offer a sixth, optional Base*64 resolution image of 4096x6144 pixels. That's why the photographs digitized onto Pro Photo CDs are sometimes referred to as "six res" scans and cost more than five-res scans.

Kodak Photo CD

Most outlets allow you to scan medium- and large-format images onto a Pro Photo CD at the same five-res scans as a standard Photo CD master disk, although typically the prices are higher but less than a six-res scan. There is also a difference in the dynamic range of the scans made using the different processes. A Photo CD master disk scan, for example, has a dynamic range of 2.8, while a Pro Photo CD scan is 3.2.

High-quality scans are possible from either negatives or slides, although I have been told that negative film produces better results because its dynamic range more closely matches the dynamic range of the scanner used in the Photo CD process. This means that all of the information in the negative should be captured in the digital file. Slide film has a greater range than negative film and there may be some loss of data, but my experience has not shown any loss to be significant or noticeable, even in large reproductions.

Above left: Black and white imagery has made a strong comeback. Some argue that this type of imagery has more nuances and emotion than color photography.

Above right: The same models in full technicolor. Flesh tones combined with the contrasting white clothing make for an arresting shot.

Tip: Where to get images digitized. There are many outlets who will transfer your film files onto a Photo CD. To find one near you, use the search mechanism on Kodak's Web site, www.kodak.com. The cost of this service varies by provider, with 35mm prices ranging from 50¢ an image up to $3 each. For medium- and large-format film, the prices can range from $10 to $20. Most dealers charge a onetime setup charge for the disk, depending on how many images you initially digitize. It's usually more cost-effective to transfer the images to the Photo CD immediately after film processing but before the negatives have been cut into shorter strips or the transparency film placed in slide mounts.

Kodak Photo CD acquire module

While you can use your image-editing program's Open command, you can also access images on Photo CDs using the Kodak Photo CD Acquire Module plug-in. The biggest advantage of using this approach is that the plug-in lets you manipulate an image before it's actually opened. For example, you can convert an image into black and white, crop, and sharpen it before opening the image. If the image is in color but you need it to be in black and white (in a newsletter, for example), you can open it that way. A black-and-white image takes one-third less disk space than a color one.

When you select the Photo CD Acquire Module from your image-editing program's Import menu, a dialog box shows a thumbnail of the images that are available, allowing you to choose not only which image you want to open, but at what specific resolution. The minimum

choice might be the Base (512x768) image, but if you have enough memory in your computer, working with the larger Base*16 (2048x3072) will produce better-quality results when printing. Controls in the Photo CD Acquire Module's dialog box let you change the image's orientation—all Photo CD images are scanned in landscape mode—and you can use a four-level Sharpening menu to sharpen the image while it's being opened. The best way to use the Photo CD Acquire Module's cropping function is to do a rough crop of the thumbnail in the dialog box, then click the Preview button and fine-tune the cropping using the larger image found there.

A free Photo CD Acquire Module plug-in is available for both Microsoft Windows and Mac OS-based computers, and you can download the latest version from www.kodak.com on the World Wide Web.

Tip: Compression makes the file smaller
Compression is a software technique that makes digital photographs smaller by reducing the amount of unneeded space in an image file. As file sizes increase, greater demands are made on all of your computer's resources, which is why

compression technology was invented. Compression is also an important aspect of image capture using digital cameras.

Top Left: What's your angle? These four images were chosen to show how image-editing tools can greatly influence the mood and tone of similarly composed pictures. This image has been cross-processed to achieve this look.

Bottom left: Additional black has been added for more contrast.

Top right: Extra helpings of cyan give this image its other-worldly presentation.

Bottom right: The cross process can now be done in either in the dark room or by use image-editing software.

Opposite: The Windows version of the Photo CD Acquire Module looks almost identical to the Macintosh version and has all of the same functions and controls.

Acquisition alternatives

An alternative way to acquire an image from a Photo CD is by using LaserSoft SilverFast Ai Photo CD plug-in. SilverFast Ai (Artificial Intelligence) is part of a family of image-capture plug-ins that also supports various manufacturers' scanners. SilverFast Ai Photo CD lets you acquire images from either a standard or Pro Photo CD, and you can modify them by using the kind of powerful tools and capabilities normally found in scanner plug-ins.

SilverFast Ai has a two-level user interface: In ScanPilot mode, a novice user is guided step-by-step through the capture process, while more experienced users can work with numerical input and check the exact values using the plug-in's built-in densitometer. All operations are done in real time, allowing you to immediately see the effect of any changes you make and undo any unwanted modifications. The plug-in has a Pre-Scan feature that lets you rotate and resize the image before it's acquired by your image-editing program. A Job Management feature lets you organize a project that can include many different Photo CD image scans, so you can tweak all of the images in the shortest possible time. You can download a demo version of the Macintosh or Windows version of the plug-in from LaserSoft's Web site at www.lasersoftint.com.

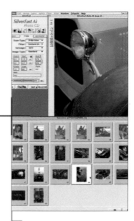

Top: Once an image has been selected, a large preview window allows you to crop, resize, and tweak the image using any of SilverFast Ai Photo CD's controls, including the ability to apply Unsharp Masking as the image is being imported into your image-editing program.
Photo © Joe Faracè.

Bottom: The Open function of SilverFast Ai Photo CD lets you preview thumbnails for all of the images on the Photo CD. You can load an image by selecting it—which points a small red frame around the thumbnail—then clicking the OK button.
Photo © Joe Farace.

Left: Tinted images with tight crops make for a spectacular result.

Picture CD is an auto-loading CD-ROM that incorporates digitized photographs along with image-manipulation software to let you work with those digital images. After inserting the CD-ROM in a Windows computer, the software automatically launches, and all of your digitized pictures will appear on the monitor. On a Macintosh computer, you need to click the "StartMac" icon, and the features on the Mac OS are much more limited than those in Windows. For example, on Windows, the disk's features are displayed in a magazine-style format, using a table of contents, with on-screen instructions to guide you through the CD's various options.

Each picture disk holds images from a single roll of film. Ordering this digital service is as simple as checking a box on the film-processing envelope provided by your local photofinisher. After processing, which can vary from one hour to two days depending on the retailer, you will receive prints along with a Kodak Picture CD disk and an index print in the CD's sleeve—all in the same envelope.

The software on the Windows version lets you view and tweak your images; on the Mac OS version, you can just save the files to your hard disk. You can rotate your digital photographs as well as add text or captions. The software also lets you create full-screen slide shows utilizing special transition effects between the images. You can print single or multiple pictures as well as "package print" a single image at different sizes and quantities. If you want to send an image by e-mail, you can copy one or more of your pictures onto your hard drive, then attach those images to a message. You can find more information about Picture CD at www.kodak.com.

Kodak Picture CD

Top left: Be sure to include the photographer in some of your travel pictures!

Top right: In the frame. Close cropping makes this image more evocative.

Right: The Kodak Picture CD disk can be ordered at the same time that you have your color negative film processed. When the photofinisher returns your prints, you will also receive a CD-ROM containing all of the images from that roll.

Differences between Picture CD and Photo CD

There are some similarities between Picture CD and Photo CD: They both feature a resolution of 1536x1024 from 35mm film or 1536x864 from Advanced Photo System film. A Photo CD typically holds about 100 five-resolution files. A Picture CD holds images from one roll of 36-exposure film, and the disks are made only at the time of processing. The reason for this lower capacity is that Picture CDs include digital imaging software.

Picture CD is designed mostly for Windows-based computers, while Photo CD image files can be read by both Macintosh and Windows computers. I say "mostly," because the Picture CD itself is recognized by Mac OS computers, and Macintosh users can open the JPEG images on the disk using their favorite image-editing programs. What Mac users cannot do is access all of the software that Kodak has added to the Picture

CD. Photo CD is generally used by the professional, and Picture CD is aimed at the amateur photographer. All of the differences that exist between Picture CD and Photo CD have more to do with their intended audiences than anything else.

Kodak Picture Disk
The Kodak Picture Disk process digitizes images from negative film and stores them on a floppy disk along with software that lets you view, print, and export these photographs to other programs such as word processing programs. The maximum number of images that can be placed on a single floppy disk is 28, with a resolution of 400x600. If you shoot a 36-exposure roll, all of the additional images are digitized and placed on a second floppy disk. Picture Disk is only available for 35mm color negative film.

Top: Expressionistic. One model—three pensive expressions.

Bottom: By changing the angle and the color saturation of the background, the second image has more impact.

Right: To get the blurred effect shown, you can use Adobe Photoshop by first using the dupe layer and adding a Gaussian blur.

While Kodak offers scanning services through its many dealers and affiliates, Kodak is by no means the only option available for those looking for image-digitizing services. Here are a few places that you might want to check out.

Seattle FilmWorks (www.sfw.com) offers a digitizing service called High Resolution Pictures on Disk that produces 500x1000 resolution images from color negative film when they are made at the time of processing. Their original digital service, now called Standard Pictures On Disk, delivers 768x512 pixel images on a floppy disk and provides a color depth of 24 bits with 16,777,215 colors. Instead of a standard file format, Seattle FilmWorks uses a proprietary file called "sfw" that includes indexing, captioning, and description features. The company offers a free Windows-only image-editing program called PhotoWorks that lets you access their images and offers a low-cost upgrade version called PhotoWorks Plus that lets you convert your original files into other image file formats.

While the specifications for High Resolution Pictures on Disk are similar to the Kodak Picture CD process, there is a difference in how the actual digitizing is accomplished. Kodak scans the original negative film, while Seattle FilmWorks scans the 3x5 or 4x6 prints that are part of your order. Scanning the prints adds another generation and another variable to the image-capture process; if the prints are good, your digital images will be, too.

A service that's offered by many photofinishers is scanning images and delivering them on a standard 3-1/2-inch floppy disk. Typically this is available for both Windows and Macintosh products, and the system uses conventional JPEG compression techniques. Digital images can be made from unprocessed film as well as existing negatives, slides, or prints. Check with whoever is currently processing your film to see if they offer this service.

Digitizing service alternatives

Top: This angular compositional structure uses a pure cross of horizontal and vertical lines to achieve a sophisticated result.

Right: Smokin'! The slow upward motion of smoke adds interest to this textural picture.

Opposite: Seattle FilmWorks' free PhotoWorks software allows you to catalog, edit, and print your digital images created with the company's Windows Pictures On Disk service. A free Mac OS format plug-in can be downloaded from the company's Web site.

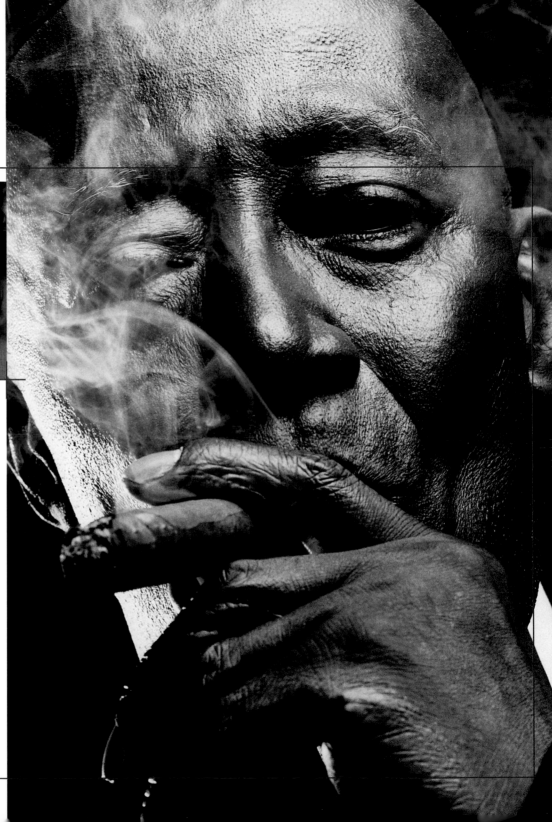

Glossary

Aliasing:
When a graphic is displayed on a monitor, you will sometimes see jagged edges around some objects. These extra pixels surrounding hard edges—especially diagonal lines—are caused by an effect called aliasing. Techniques that smooth out these edges, called "jaggies," are referred to as anti-aliasing.

Analog:
Information presented in continuous-tone format, corresponding to a representation of the "real world." A traditional photographic print is an analog form, but when this same image is scanned and converted into bits, it is then in digital form.

Archive:
To copy any kind of data from the media it is currently stored on, typically a hard disk, onto a removable media cartridge or tape for backup purposes. Archive and backup software often compress this data to maximize the capacity of that storage media.

ASCII:
American Standard Code for Information Interchange. ASCII is a standardized computer code for representing text data. The code has 96 displayed characters that you see on the screen and 32 nondisplayed characters, some of which you can see, others that you can't.

Binary:
A mathematical system based on the numbers one and zero. This system is ideal for use by computers, because signals can be represented by electrical current being positive and negative, on and off.

Bit:
A binary digit. The smallest unit of information with which a computer can work. Computers are digital devices because they represent all data—including photographs—using numbers, or digits, that are measured in bits.

Bitmap:
There are three classes of graphic files: bitmap, metafile, and vector. A bitmap (sometimes called a "raster") is any graphic image that is composed of a collection of tiny individual dots or pixels—one for every point or dot on a computer screen. The simplest bitmapped files are monochrome images composed of only black or white pixels. Monochrome bitmaps have a single color against a background, while images displaying more shades of color or gray need more than one bit to define the colors.

BMP (often pronounced "BUMP"): Short for "bitmap," BMP is a file extension for a specific kind of Windows-based bitmapped graphics file.

Byte:
Each electronic signal is only one bit, but to represent more complex numbers or images, computers combine these signals into larger 8-bit groups called bytes. When 1024 bytes are combined, you get a kilobyte (K).

Calibration:
A term used in Color Management Systems (CMS). Calibration stabilizes the inevitable variables in the way a device reproduces color. To produce optimum results, all color-reproducing devices must maintain a consistent, calibrated state. A variety of calibration products are available depending on the device and manufacturer. Some monitors include the necessary hardware and software to maintain color calibration.

CCD:
Charge-Coupled Device. This is the kind of light-gathering imaging sensor used in flatbed scanners, digital cameras, and video camcorders to convert the light passing through a lens into the electronic equivalent of the original image.

Clock speed:
The clock circuit of a computer uses vibrations generated by a quartz crystal, not unlike the one in a quartz wristwatch, to send a stream of pulses to the CPU (central processing unit). You can spot the clock on your computer's motherboard; it looks like a tiny sardine can. How fast the CPU of a microcomputer operates is measured by its clock speed, which is rated in megahertz (MHz), or thousands of cycles per second. The faster the clock speed, the faster the CPU can process data.

CLUT:
Color Look-Up Table. A table—it can be found in hardware or software form—that contains information on the mixing of red, green, and blue in a color palette.

CMYK:
Cyan, Magenta, Yellow, and Black. These are the four process colors used by commercial presses to re-create the appearance of a full-color photograph on the printed page. The printed colors are created using different percentages of cyan, magenta, yellow, and black. When the page is printed, the combination of the different-sized colored ink dots create the illusion of colors. The separation of cyan, magenta, yellow, and black (known as four-color separation) can be done by desktop color systems and page-layout programs.

Compression:
This is a method of removing unneeded data to make a file smaller without losing data, or in the case of a photographic file, minimizing image-quality loss. Having a smaller file while retaining image quality means that your hardware can work with the files faster, and you can store more images on your hard disk.

CPU:
Central Processing Unit. There are two basic families of CPUs: Intel and Motorola. Intel and similar chips from companies such as AMD are used in Windows-compatible computers, while Motorola makes the chips found in Mac OS machines. How well a chip processes data is determined by how many bits of information it can process at one time. The larger the number of bits a chip can process simultaneously, the faster it can process. Think of it as a highway: The more lanes you provide, the more cars that can travel on it at one time. A 32-bit CPU, for example, processes data twice as fast as a 16-bit model. The next most important aspect of the CPU is how fast it processes data. This is measured by the CPU's clock speed. Using the highway example, the clock speed would define how fast the cars can travel on those lanes.

Device resolution:
Refers to the number of dots per inch (dpi) that a device, such as a monitor or printer, can produce. Device resolution for computer monitors varies from 60 to 120 dpi. Do not confuse this with "screen resolution," which refers to the number of dots per inch in the line screen used by commercial printing companies to reproduce a photograph. Screen resolution is measured in lines per inch (lpi). "Image resolution" refers to the amount of information stored in a photograph and is sometimes expressed by some hardware manufacturers in pixels per inch (ppi). Image resolution of a photograph is important, because it determines how large the file will be. The higher the image resolution, the more disk space the file will occupy and the longer it will take to output.

Dialog box:
This is a window that occasionally appears in many programs to allow users to communicate with the software in order to achieve a specific result. The most basic dialog box is one that appears when you give the Print command. By entering data in this window, you instruct the printer how many

copies to print, in what order, and whether you want the image printed in color or black and white. Dialog boxes, or dialogs for short, are important when working with plug-ins with image-manipulation programs such as Adobe Photoshop. In this situation, the dialog box lets you specify how an image will be enhanced and gives digital photographers control over how their final image will look.

Dither:
A graphics display or printing process that uses a combination of dots or textures to create the impression of a continuous-tone grayscale or color image.

DPI:
Dots Per Inch. This is a measurement of resolution for a printer, a scanner, or an image file. If a device has a resolution of 300 dpi, it means that there are 300 dots across and 300 dots down. The tighter this cluster of dots is, the smaller the dot becomes. The higher the number of dots, the finer the resolution will be.

Dynamic range:
One feature to look for in a scanner is its dynamic range. A scanner's dynamic range depends on the maximum optical density that can be achieved and the number of bits it can capture. In simple terms, the greater the density range, the better the scanner. Until recently, only expensive slide scanners offered a density range over 2.5, but now more affordable scanners perform at 3.0 or higher. By comparison, a standard Photo CD scan has a dynamic range of 2.8.

EMF:
Electromagnetic Field. If you spend more than a few hours at your computer a day, you should be aware of the potential problems caused by the electromagnetic fields that computer monitors produce. All monitors emit some kind of very low frequency (VLF) and extremely low frequency (ELF) radiation, and color monitors emit

more than monochromatic ones. A cathode-ray tube releases most of its radiation from the sides and back of the monitor. That's why it's a good idea to sit four or five feet away from your monitor. For most people this may not be possible, but you should at least keep it at arm's length. You will sometimes see screen filters that purport to block radiation from computer monitors, but even lead can't stop some ELF and VLF waves.

EPP:
Enhanced Parallel Port. See Parallel Interface.

Film recorder:
Color film recorder, sometimes called CFR. A desktop film recorder is essentially a camera enclosed in a small box and focused on a very high-resolution black-and-white monitor. The CFR makes three exposures of the image through separate red, green, and blue filters to produce the final image. This can be a slow process.

Flashpix:
Originally developed by Kodak, Hewlett-Packard, Live Picture Inc., and Microsoft, FlashPix is an open industry standard file format for digital imaging. It is built around a multiple-resolution image file format that uses Microsoft's OLE (Object Linking and Embedding) structured storage. FlashPix makes it practical to use high-quality pictures on the average Windows or Macintosh computer. You can work with a low-resolution image on-screen and access a higher-resolution version to get great-looking output after finishing your manipulations. Since software and hardware that support FlashPix automatically chooses the appropriate resolutions, the technology will be invisible to the end user. The only problem with this format is that, like Sony's Betamax, it has never caught on with many users.

Gamma:
The amount of gamma present in an image is measured as the

contrast that affects the mid-level grays (the mid-tones) of an image. This gamma is adjustable by most image-enhancement programs, and you aren't stuck with the gamma that is present in the original negative or print.

GIF (pronounced "jif"):
Graphics Interchange Format. Originally developed by CompuServe Information Services, this format is completely platform-independent; the same bitmapped file created on a Macintosh is readable by a Windows graphics program. A 256-color GIF file is automatically compressed, making it ideal for use on the World Wide Web.

Gigabyte:
A billion bytes, or, more correctly, 1024 megabytes.

Grayscale:
Refers to a series of gray tones ranging from white to pure black. The more shades or levels of gray, the more an image will look like a full-tone black-and-white photograph. Most scanners will scan 256 or more gray tones. Grayscale image files are typically one-third the size of color ones.

GUI:
Graphical User Interface.

Halo:
When using a selection tool in an image-enhancement program to select certain kinds of objects, a halo can appear around part of that selection. These extra pixels can be created by the program's anti-aliasing feature. Most image-enhancement programs have a built-in anti-aliasing function that partially blurs pixels on the fringe of a selection and causes additional pixels to be pulled into the selection.

Hard disk:
A computer's hard drive consists of one or more rigid (hard) nonflexible disks. Like the floppy disk drive, it has a read/write head or multiple heads on multidisk

drives. Once data is written to it, you can think of your hard drive as a file cabinet that holds all the data inside your computer. Like a file cabinet, you can access this data whenever you want, and it's still there after you shut the computer down. The capacity of hard disks is measured in megabytes, but unlike the 1.44MB that's standard for floppy disks, hard drives come in many sizes. Any computer you buy will already have a hard disk installed, and until you outgrow the hard drive (which will be sooner than you think), you won't have to worry about replacing it. Fortunately, prices of hard disks have dropped as fast as the need for greater storage capacity has grown.

HTML:
Hypertext Markup Language. This format is used on home pages on the Internet using multimedia techniques to make the Web easy to browse.

Indexed color:
There are two kinds of indexed color images: those with a limited number of colors and pseudocolor images. The number of colors for the first type is usually 256 or less. Pseudocolor images are really grayscale images that display the variations in gray levels in colors rather than shades of gray and are used for scientific and technical work. CompuServe's GIF format uses an indexed color scheme.

Ink-jet:
In an ink-jet printer, a printhead sprays one or more colors of ink onto paper to produce output, and the type of methods used to accomplish this can have an effect on output quality. Piezoelectric technology is based on the property of crystals to oscillate when subjected to electrical voltage. This allows printers using this technology, such as Epson's Stylus Color family of ink-jet printers, to place uniform ink droplets on paper and deliver output at up to 1440 dots per inch (dpi) resolution or higher. The drop-on-demand

method uses a set of independently controlled injection chambers—the newest of which use solid ink—that liquefy when heated and solidify when hitting the paper. Canon, HP, and some others favor this thermal approach. Another method is the continuous stream method, which produces droplets aimed onto the paper by electric field deflectors. The weak link of all ink-jet printers, large or small format, is the fading from UV radiation and susceptibility to water damage. These limitations can be overcome by laminating the finished print.

JPEG:
An acronym for a compressed graphics format created by the Joint Photographic Experts Group, within the International Standards Organization. Unlike other compression schemes, JPEG is a "lossy" method. By comparison, the LZW (Lempel-Ziv-Welch) compression algorithms that are used in file formats such as GIF are lossless, meaning no data is discarded during compression. JPEG achieves compression by breaking an image into discrete blocks of pixels, which are then divided in half until a compression ratio of from 10:1 to 100:1 is achieved. The greater the compression ratio, the greater loss of sharpness you can expect.

K:
In the computer world, K—kilobyte, or KB—stands for 1024 bytes.

Landscape (mode):
An image orientation that places a photograph across the wider (horizontal) side of the monitor or printer. A photographer would call this a horizontal image, but a computer user would say "landscape." Antonym: portrait or vertical.

LZW:
Lempel-Ziv-Welch. A compression algorithm currently owned by UNISYS.

Macintosh:
There are two general classes of small computers: those built to the IBM standard and those that comply with the Mac OS standard. Apple Computer's personal computer, introduced in January 1984, was the first popular computer—the ill-fated Xerox Star was probably the first—to use a combination of a graphical user interface and mouse pointing device.

Mask:
Many image-enhancement programs have the ability to create masks, or stencils, that are placed over the original image to protect parts of it and allow other sections to be edited or enhanced. Cutouts or openings in the mask make the unmasked portions of the image accessible for manipulation while the mask protects the rest.

Megabyte:
When you combine 1024 kilobytes, you have a megabyte (MB) or "meg."

Metafile:
This multifunction graphic file type accommodates both vector and bitmapped data within the same file. While seemingly more popular in the Windows environment, Apple Computer's PICT format is a metafile.

Moiré (pronounced "mwah-RAY"): Moiré patterns are an optical illusion caused by a conflict with the way the dots in an image are scanned and then printed. When scanning an original photograph or artwork, a single-pass scanner is all most people require, but when scanning material that has previously been printed, a three-pass scan (one each for red, green, and blue) will almost always remove the inevitable moiré or dot pattern.

Nano:
A prefix that means "one-billionth."

Parallel interface:
A type of port typically found on PCs used for connecting printers, scanners, and other peripheral devices. The parallel reference means that data—several bits at a time—is simultaneously sent and received over individual but adjacent wires.

PC-compatible:
A personal computer compatible with the original IBM-PC standards, originally used in the early years of personal computing when the amount of compatibility varied greatly. Today's PC-compatibles conform to standards originally set by IBM, but over time they have been modified by the industry itself. Sometimes you will hear such computers called "clones," but that term has taken on a pejorative tone as computer makers, such as Compaq, regularly outsell IBM-brand computers.

PCX:
Not an acronym (it doesn't stand for anything specific), a bitmapped file format originally developed for a specific program called PC Paintbrush. Most popular Windows graphics programs read and write PCX files.

Photo CD:
Kodak's proprietary process that places digitized files of photographs onto a CD-ROM. A Photo CD Transfer Station converts analog images into digital form by using a high-resolution film scanner, a computer, image-processing software, a disk writer, and a color thermal printer. Each image is adjusted for color and density, compressed to 4.5MB using Kodak's proprietary Photo YCC format image, and written to a CD-ROM. A thermal printer creates an index sheet showing the images transferred to disk, and this is inserted into the cover of the CD's case. The Photo CD master disk format can store 100 high-resolution images. The disk writer writes five different file sizes (and five different resolutions) onto the CD.

A subset is the Pro Photo CD disc, which offers a sixth resolution.

Pixel:
Short for "picture element." A computer's screen is made up of many thousands of these colored dots of light that, when combined, can produce a photographic image. The width and height of the image as measured in pixels indicate a digital photograph's resolution, or visual quality. When a slide or negative is converted from silver grain into pixels, the resulting image can be produced at different resolutions.

PNG (pronounced "PING"):
Portable Network Graphics. This was supposed to be the successor to the GIF format widely used on the Internet and online services. In response to the announcement from CompuServe and UNISYS that royalties would be required, a coalition of independent graphics developers from the Internet and CompuServe formed a working group to design a new format that was called PNG.

QIC:
Quarter-Inch Cassette. For some reason, tape is more popular with Windows and DOS users than with Mac OS users. This is changing as multi-GB drives become less expensive and the thought of backing up these huge drives sinks in. Cartridges come in different designations: there are QIC (Quarter-Inch Cassette), XL (long), and QW (wide-long) models, and variations on these names that sound more like the latest model BMW. Data is stored on the tape in serial forms instead of in the random method used by all other forms of removable media. This produces inherently slower access times, which prevent magnetic tape from getting all of the respect it deserves.

RAM:
Random Access Memory. RAM is that part of your computer that temporarily stores data while you are working on an image or text file.

Unlike a floppy disk or hard drive, this data is volatile—if you lose power or turn off your computer, the information disappears. Most contemporary computer motherboards feature several raised metal and plastic slots that hold RAM in the form of SIMMs (single inline memory modules) or more likely, DIMMs (dual inline memory modules).

Removable media:
Removable media drives are computer peripherals that use data storage cartridges that can be removed from the drive and have many advantages for computer users, especially digital photographers. Sometimes called removable hard drives, they are more correctly called removable media, since the media being removed might be optical as well as magnetic. You can use them for many different tasks, such as backups of specific data on your hard disk. Without removable media, digital photographers wouldn't have a way to take large image files back and forth to a service bureau. Placing data on removable media and locking it in a safe-deposit box provides a level of security even the most ardent hackers can't breach.

Resampling:
The process of increasing or reducing the number of pixels in a digital image file so that it conforms to a new size or resolution. This is typically accomplished in an image-editing program's Image Size (Adobe Photoshop) or Dimension (Ulead PhotoImpact) dialog box.

Resolution:
A digital photograph's resolution, or image quality, is defined as an image's width and height as measured in pixels. When a slide or negative is converted from silver grains into pixels, the resulting digital image can be made at different resolutions depending on the digitizing device or technique used. The higher the resolution of an image—the more pixels it has—

the better the visual quality. An image with a resolution of 2048x3072 pixels has better resolution and more photographic quality than the same image digitized at 128x192 pixels. Unfortunately, as the resolution of a device increases, so does its cost.

RGB:
Red, Green, and Blue. Color monitors use red, green, and blue signals to produce all of the colors that you see on the screen. If you have ever made Type R prints from slides in your darkroom, you are familiar with working with the additive color filters of red, green, and blue.

Saturation:
Often referred to as chroma, saturation is a measurement of the amount of gray present in a color.

SCSI (pronounced "SCU-zee"):
Small Computer System Interface. This 8-bit computer interface allows for the connection of up to seven peripheral devices to a single port. SCSI has been standard on all Macintosh computers since the introduction of the Mac Plus in 1986 but disappeared with the introduction of the Power Macintosh G3 and iMac. It is not typically standard on Windows computers, but any computer lacking a SCSI port can install a SCSI expansion board. Popularity has diminished since the introduction of the Universal Serial Bus, even though that standard is slower.

Service bureau:
This is a term left over from the old days of computing when few people could afford to own computers. Users had to take their data, usually in punched-card form, to companies which did own computers to process their data for a fee. Today's service bureaux can digitize your analog photographs using scanners or the Kodak Photo CD process to turn digital images into analog form, including prints, slides, or negatives. A service

bureau can take many forms. It can be a small, specialized facility that only provides Kodak Photo CD service, or a large commercial photographic lab that offers a wide range of digital input and output services.

Thermal dye transfer:
Often called dye sublimation, this printer type uses a head that heats a dye ribbon to create a gas that hardens into a deposit on the special paper used by the printer. Like most printers, it forms "dots" of colors, but because these spots are soft-edged (as opposed to the hard edges created by laser and ink-jet printers), the result is smooth, continuous tones.

Thumbnail:
This is an old design-industry term for "small sketch." In the world of digital photography, thumbnails are small, low-resolution versions of your original image. Since they are low resolution, they produce extremely small files.

TIFF:
Tagged Image File Format. This is a bitmapped file format originally developed by Microsoft and Aldus. A TIFF file (.TIF is the extension used in Windows) can be any resolution from black and white up to 24-bit color. TIFFs are supposed to be platform-independent files, so files created on a Macintosh can (almost) always be read by a Windows graphics program.

TWAIN:
A hardware/software standard that allows users to access scanners from inside software applications. In addition to scanning, typical TWAIN software allows users to adjust brightness and contrast.

Universal serial bus:
The Universal Serial Bus (USB) standard was created in 1995 by a consortium that included Compaq, DEC, IBM, Intel, Microsoft, NEC, and Northern Telecom. USB was originally designed to provide an interface between computers and

various peripherals over inexpensive cables. USB supports daisy-chaining and can connect multiple devices through one or two ports on the host computer, in much the same way Macintosh users have always connected keyboard, mouse, and graphics tablet via the Apple Desktop Bus (ADB).

Unsharp mask:
This oddly named function is a digital implementation of a traditional darkroom and prepress technique in which a blurred film negative is combined with the original to highlight the photograph's edges. In digital form, it's a more controllable method for sharpening an image.

Vector:
Images saved in this format are stored as points, lines, and mathematical formulae that describe the shapes that make up that image. When vector files are viewed on your computer screen or printed, the formulae are converted into a dot or pixel pattern. Since these pixels are not part of the file itself, the image can be resized without losing any quality. Vector files use the same technology that Adobe uses with its PostScript fonts and have the same advantages—you can make any image as big as you want, and it retains its quality. Vector graphics are displayed as bitmapped graphics on your monitor. Photographs are not typically saved in this format. Some computer users, especially Mac OS users, call vector format files "object-oriented," and you will often see that term used on graphic drawing programs.

Windows:
More properly called Microsoft Windows, it is an attempt to make the DOS (Disk Operating System) command-line interface more user-friendly by providing a graphical user interface. The original Windows was announced in 1985, but this operating environment

didn't become the de facto standard for IBM-compatible computers until the creation of Windows 3.0 in 1990. Unlike the Macintosh GUI, the original version of Windows was more accurately called an operating environment instead of an operating system, since it required users to have Microsoft's DOS installed. This requirement vanished with the introduction of Windows 95, which no longer required DOS (after installation) but provided access to a DOS-like environment for use of older non-Windows applications.

WYSIWYG (pronounced "WISS-y-wig"):
What You See Is What You Get. This term refers to the ability to view text and graphics on the screen in the same manner as they will appear when printed. While most text and image-editing programs have WYSIWYG capabilities, not all do. Read the fine print when you think about purchasing any program.

XGA:
A type of video adapter developed by IBM for its PS/2 computers. XGA displays a resolution of 1024x768 pixels with 16-bit colors, allowing it to display 65,000 colors.

YCC:
The color model used by the Kodak Photo CD process. This is the translation of RGB data into one part of what scientists call "luminance" but the rest of us call "brightness." This is the Y component that is added to two parts—the CC—of chrominance, or color and hue. This system keeps file size under control while maintaining Photo CD's "photographic" look.

Zip:
Iomega's Zip removable media drive has a street price of around $100, using a combination of conventional hard disk read/write heads with flexible disks and producing an average seek time of 29 ms. Pocketable Zip cartridges, scarcely larger than a floppy disk,

are less expensive than other removable media.

.Zip:
A Windows-based compression scheme that is used to create an industry standard archive called a .ZIP file that can be made from one or more files using PKWare's PKZip or compatible software.

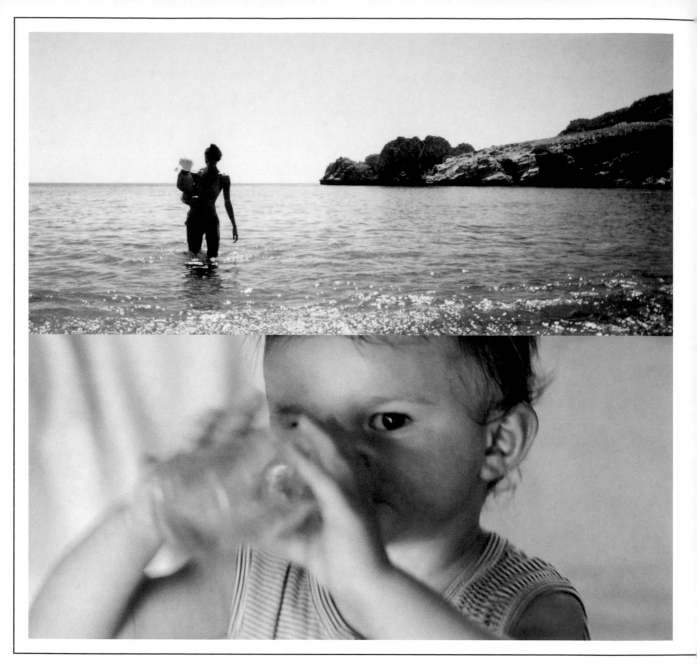

Digital Vision gallery

Images throughout this
publication, unless otherwise
noted, have been provided by
Digital Vision. Featured
photography can be found on
these CD titles: A Family is Born,
Quirky Kids, ...And Baby Makes
Three, Living Life, Up Close and
Personal, Urban Leisure, and
Love.

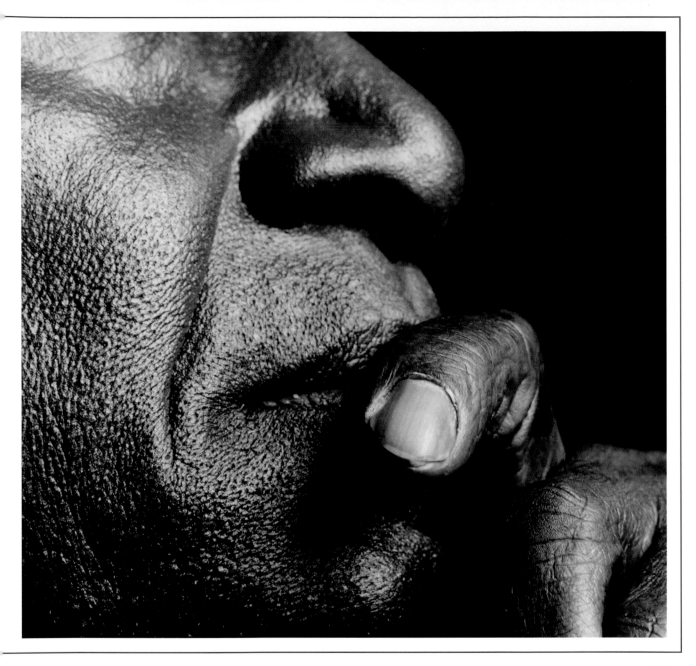

Acknowledgments

There were also a number of people from companies that produce digital imaging products who went beyond the normal call of duty to help me with this book series. They include: Epson's Reena Spector, Olympus's Karen Thomas, and Dave Podwicka from Eastman Kodak Company. Thanks also to Colleen Henley of Hewlett-Packard for supplying several digital images made with their cameras. A special thank-you goes out to Agfa's Ben Abbatiello for supplying me with technical information about the company's camera and scanner products, as well as some of the great-looking images made with Agfa digital cameras that you will see in the book. This book never would have been published without the help and encouragement of Silver Pixel Press's Marti Saltzman. Many thanks, Marti, for asking me to write it. I would also like to thank my own support team, who have inspired me and bailed me out of technical problems during the process of writing this book series. This includes legendary camera technician Vern Prime, who has been a constant source of technical information about computers and a helping hand whenever I needed one. Kevin Elliott is the general manager of Photobition and combines a photographer's skills with the common sense of a person who can fix anything. Lastly, I would have never been able to complete this book—or any of my others—without the continued love and support of my dear wife, Mary. She is my biggest fan, and for that, I will always be grateful.